IMAGES
of America

CINCINNATI TELEVISION

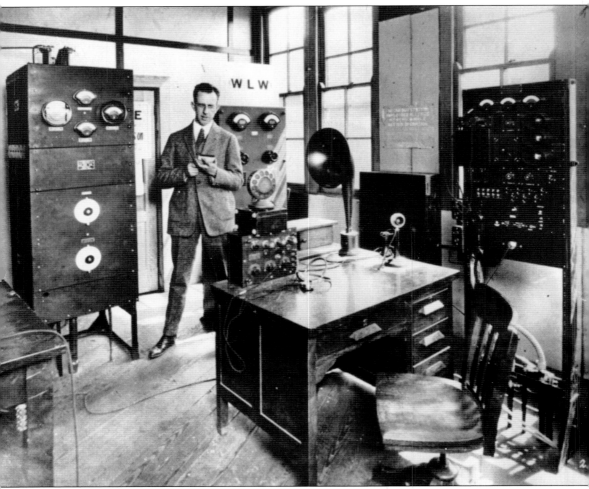

Why begin with a man who always has been considered a pioneer of radio broadcasting rather than of television? Powel Crosley was an innovator with many interests. He invented the refrigerator with shelves in the door, the hair restoration machine, and the car radio. But most importantly, he spent 24 years creating the most powerful listener-friendly radio operation in the world. Although he sold his broadcast empire in 1945, three years before WLW-T signed on, it was under Crosley that the experimentation of Cincinnati television began. Crosley's WLW radio established the standard for top local news and entertainment, the model WLW-T followed for decades. (Courtesy WLWT.)

On the cover: Almost a half million Cincinnatians have a story to share about their appearance on *The Uncle Al Show*. During its 35 years on WCPO-TV, many youngsters did the twist, danced the "Hokey Pokey," and sang "Zip-A-Dee-Do-Dah." One little girl "winkied" on "Uncle Al" Lewis's accordion. In 1956, the children helped Uncle Al and Cinderella, played by Janet Greene, promote Soft Bread. (Courtesy WCPO.)

IMAGES
of America

CINCINNATI TELEVISION

Jim Friedman

ARCADIA
PUBLISHING

Published by Arcadia Publishing
Charleston SC, Chicago IL, Portsmouth NH, San Francisco CA

Printed in the United States of America

Library of Congress Catalog Card Number: 2007932659

For all general information contact Arcadia Publishing at:
Telephone 843-853-2070
Fax 843-853-0044
E-mail sales@arcadiapublishing.com
For customer service and orders:
Toll-Free 1-888-313-2665

Visit us on the Internet at www.arcadiapublishing.com

*To Mom and Dad, for introducing me to television, taking me to
The Uncle Al Show, fostering my love of broadcasting, creativity,
storytelling, and writing . . . and for telling me to stop watching
television and do my homework.
And to Zachary and Tyler—my heroes and my inspiration. You breathe
life into every word I write, every show I produce, and every story I
tell . . . Now, stop watching television and do your homework.*

CONTENTS

ACKNOWLEDGMENTS

Producing a book is like producing a television show. So many people gave their support and direction, often at the most critical times. So before the show begins, I want to roll credits for those who gave their time, memories, and photographs to share this history of Cincinnati television.

Thanks to Clyde Haehnle for his early images and stories. Thanks to WLWT's Richard Dyer and Lisa Snell and the Cincinnati Museum Center's Scott Gampfer, Linda Bailey, and Dan Hurley. Special thanks to my Scripps family, including WCPO-TV's Bill Fee and Allen White; the *Cincinnati Post*'s John Vissman and Bob Hahn; and Sue Porter at the Scripps Howard Foundation.

Thanks to "Uncle Al" Lewis and Wanda "Captain Windy" Lewis, David Ashbrock, Kay Barksdale, Dave Bartholomew, Rick Bird, Bernie Borden, Wray Jean Braun, George Bryant, Nick and Nina Clooney, Rosemary Kelly Conrad, Regina Ward Copenhaver, Don Dahlman, Janet Davies, Faye Dorning, Bernie Dwertman, Len Goorian, Suzie Maher Haas, Dennis Hasty, Grace Hill, Rosemary Holland, Michael Jaggers, John Kiesewetter, Dave MacCoy, Dotty Mack, Tom McCarthy, Gene McPherson, Marianne Myers, Bill Nimmo, Claire Richart, Michael Sanders, Cheri Schnitker, Angelica Seacup, Judy Perkins Sinclair, Brian Snape, Bill Spiegel, Dudley Taft, Mary Lynn Tangi, Jim Timmerman, and Paula Jane Watters.

Thanks to Arcadia Publishing's Melissa Basilone and John Pearson, who were patient with me, a first-time author who likes to agonize over style and pace and feel and flow.

Most importantly, thanks to my team, including Addie Rosenthal, who supported this effort in so many ways. Thanks to Andrea Dailey, who read and commented and listened through many changes in direction. And thanks to Bill Myers, whose red pen, proofreading, fact checking, and passion for the subject added so much.

I scanned 493 photographs and considered hundreds more before deciding on the 222 images presented here. There are many people, stories, and shows that I wish could be included but lack of space or of images prevented it. I hope this book brings back good memories and whets your appetite to share your stories and save your photographs so our collective histories will live on.

INTRODUCTION

Cincinnati is one of those places—a hometown—a big city full of small neighborhoods where generation after generation deepen their roots. In most places, when someone asks, "Where did you go to school?" the answer is Ohio State, Harvard University, or Northwestern University. In Cincinnati, the answer is Elder, Lakota, or Cov Cath.

One major tie that binds tristaters is television. Cincinnati has a special relationship with television. Our friends are Uncle, Skipper, and the Cool Ghoul. One generation grew up with Batty Hattie from Cincinnati, the next with *Michael's Kid's Club*. Throughout the day, our mothers watched Ruth, "Paul Baby", Bob, and even Jerry. We got our news from Peter, Al, George, Nick, and even Jerry.

Most of us attended the "Freezer Bowl" from the warmth of our living rooms. The Cincinnati family celebrated the "Big Red Machine" from home, and we all sat shivah around the television set, watching the horror of the Beverly Hills Supper Club fire. In Cincinnati, television is part of our history, part of our culture, and part of our collective memory.

It is hard to know where to start the story of Cincinnati television. For many, it officially began on February 9, 1948. WLW-T signed on to Channel 4 as the first licensed commercial television station in Ohio. But the real story began 27 years earlier in College Hill. Powel Crosley's nine-year-old son wanted a radio for his birthday. Crosley felt $130 was too much to pay for, what he perceived to be, a toy. So Crosley picked up a pamphlet titled "The A.B.C. of Radio" and built one.

Recognizing the potential of radio, Crosley began manufacturing $20 radio receivers in his Arlington Street factory and, by the following year, he was the world's largest radio manufacturer. Now that people were buying his radios, Crosley wanted to give them something to listen to. In 1922, his radio station, WLW, signed on the air. Later, with the most powerful signal in the world and Crosley's vision of bringing the best in art, music, education, and literature to millions of homes, WLW grew to be known as "the Nation's Station."

Soon people began talking about television. Few had ever seen it, but they understood the concept after Al Jolson's *The Jazz Singer* connected sound to moving pictures in the movie theater in 1927.

Few people were present on April 7, 1927, when Bell Telephone Labs and AT&T gave the first United States public television demonstration, sending pictures and sound from Whippany, New Jersey, to New York City. The main part of the demonstration was a speech by Herbert Hoover, then secretary of commerce. It was a fuzzy, jittery picture received on a 2-inch-by-3-inch screen. Newspapers called it "science's latest miracle." For the next decade, scientists and engineers worked to improve the equipment needed to make television a public reality.

In April 1937, the Crosley Corporation secured the experimental call letters W8XCT and joined the race to develop the equipment to get television on the air. Two years later, Cincinnati

saw its first demonstration of television. Crosley leased the 46th floor of the Carew Tower and shared the magic of television with members of the press.

It was at the 1939 New York World's Fair on Sunday, April 30, that television made its formal debut. The same Crosley camera used in the Cincinnati demonstration was placed in the Dumont exhibit at the fair. In the RCA Pavilion, Pres. Franklin D. Roosevelt addressed the small audience, proclaiming what was sure to become a great, new innovation. It was called the "Radio Living Room of Tomorrow."

The first Cincinnati public demonstration of television was held at the H. and S. Pogue Company department store in downtown September 18–23, 1939. Equipment from RCA was displayed, but the announcers and entertainers who performed for the demonstration were from Crosley radio stations WLW and WSAI. Crosley Corporation executives discussed Cincinnati's interest in this new medium and displayed the application for a license to televise.

Before television could move into American homes, World War II began. Factories stopped making television equipment and dedicated production lines to the war effort. Commercial television programming was canceled. With all the World War II news, few people probably noticed the headlines in the Cincinnati newspaper on November 28, 1944, datelined Washington, D.C., "The Crosley Corporation, operator of radio station WLW in Cincinnati and other radio stations over the country, yesterday asked the Federal Communications Commission for authority to construct a new television station in Cincinnati."

The war ended. The government authorized the return to television transmission testing. It is said that on June 4, 1946, there were only two television receivers in Cincinnati when Crosley engineers transmitted the first television signal from the W8XCT Carew Tower antenna. Several blocks away, engineers at Crosley Square received the image, which was a brief test pattern with no sound.

There were fewer than 100 television receivers in Cincinnati when, in July 1947, W8XCT signed on with a regular program schedule of one hour each week. When 1947 ended, W8XCT was averaging 20 hours a week. Early the following year, W8XCT was gone forever, and WLW-T was born.

Today hundreds of 24-hour cable networks deliver news, sports, cartoons, talk shows, movies, and more. In 1948, Cincinnati had one channel choice, WLW-T; and it broadcast only four hours a day. Today programming comes to Cincinnati homes either from the networks or from the local television news departments. In 1948, all programming on television was local, including talk shows, sports, children's programs, news, and game shows. Today we design rooms around wide-screen televisions. WCPO-TV pioneer Mortimer C. Watters said, "In the early days, televisions were kept in the closet. Television was an activity of choice—should we read a book, play a game, or get the television out?"

My introduction to Cincinnati television was not unusual. It was Thursday, April 9, 1959. There I was, at four years old, putting my right hand in, taking my right hand out. Like so many in Cincinnati, doing the "Hokey Pokey" on The Uncle Al Show was a rite of passage.

It was a full decade before my second television appearance. In the summer of 1969, my mother took my brother and me to the WKRC studios on Highland Avenue to sit in the studio audience of The Dennis Wholey Show. Laugh-In "Sock-it-to-me" girl, Judy Carne, was the guest on this short-lived talk show.

A decade after that, I was working in that same studio on the staff of PM Magazine. Since then I have had the privilege of meeting and working with many of the pioneers of Cincinnati television, including Watters, Al Schottelkotte, Nick Clooney, Bob Braun, Frederic Ziv, Al White, and yes, the man who gave me my start, "Uncle Al" Lewis.

The story of Cincinnati television is the story of how Cincinnati pioneers moved television sets to the center of our homes, writing the rules that forever connected a community and forever changed the face of broadcasting. This is the story of Cincinnati history, Cincinnati culture, and Cincinnati family.

One

SIGNING ON

In February 1947, there were only eight television stations on the air in the United States. In Cincinnati, W8XCT, Crosley Corporation's experimental predecessor to WLW-T, was broadcasting one hour of programming each week.

One year later, W8XCT became WLW-T, joining 27 commercial television stations across the country. It is estimated that fewer than one in 10 Americans had seen television up to that time.

Pres. William Howard Taft's nephew Hulbert Taft owned and operated the *Cincinnati Times-Star* newspaper. He had hoped his son Hulbert Taft Jr., known as "Hub," would carry on the publishing tradition, but Hub was more interested in radio. So the Taft family bought radio station WKRC and started Taft Broadcasting.

Hub attended the 1939 New York World's Fair. Excited by the television demonstration, he returned to Cincinnati to start a television station. The target on-air date was April 1, 1949, but April Fools' Day did not seem like a smart date to sign on. On April 4, 1949, WKRC-TV officially signed on.

Three months later, on July 26, 1949, Scripps-Howard Broadcasting launched WCPO-TV. Like the Taft family, E. W. Scripps Company was a newspaper organization that saw radio and then television as the wave of the future.

Exactly five years later, on July 26, 1954, WCET signed on as the first licensed public television station in the United States. On August 1, 1968, WXIX-TV became Cincinnati's fifth television station.

Most call letters have meaning. WCPO stands for the Cincinnati Post Organization. The Taft family bought WKRC from the Kodel Radio Corporation. WCET represents Cincinnati Educational Television, and WXIX refers to the Roman numerals for the number 19.

But what about Cincinnati's oldest television station, WLWT, whose call letters were taken from its radio parent? It is generally thought "WLW" was randomly assigned, unlike many other call letters. Some suggest it was Powel Crosley's promotion of his powerful signal—world's longest wave. Those who work there continue to suggest it stands for world's lowest wages.

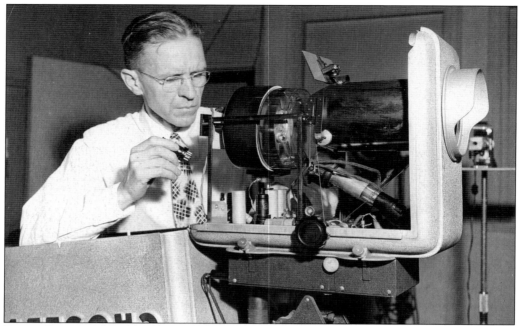

Roscoe Duncan (above) had been working for Philco in Pennsylvania when Crosley Corporation vice president Ronald James Rockwell convinced him to come to Cincinnati. Duncan designed and built a television system using this camera, placed it on the 46th floor of the Carew Tower, and broadcast under the call letters W8XCT. With only two television receivers in Cincinnati in 1939, Duncan and the Crosley Corporation engineers usually just pointed the camera out the window. The image below, captured off the monitor, shows the northeast side of downtown where the *Cincinnati Times-Star* building (left) stands at Eighth Street and Broadway. (Above, courtesy WLWT; below, courtesy the Clyde Haehnle collection.)

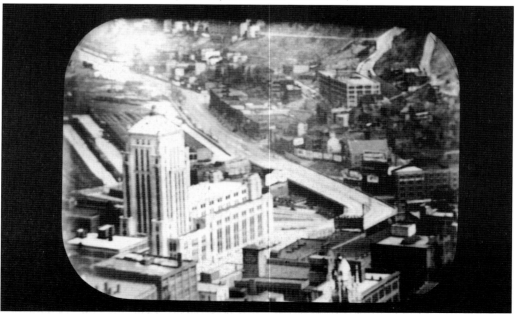

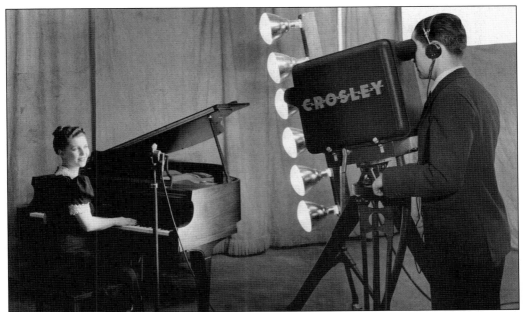

Janette Davis was best known as the singing star of Arthur Godfrey's CBS television shows from 1946 to 1957. In 1939, the Crosley Radio Corporation hired Davis to perform for experimental tests. The early television cameras were very insensitive to light, so technicians needed to put a great number of lights on Davis just to create a picture. The lights generated heat and, in a short period of time, the room filled with the smell of scorched wool from Davis's clothing. This was one of the earliest problems with the new technology; talent could be in front of the camera for only a few minutes before they were drenched with perspiration. The picture below, taken off the television screen, was considered an outstanding image in 1939. (Courtesy the Clyde Haehnle collection.)

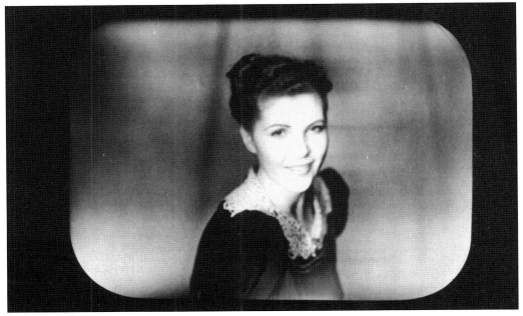

Roberta (left), Lynn, and Harris Rosedale take a bow in front of the W8XCT camera operated by Phil Underwood. The Rosedales taught dance at their downtown studio, hosted a weekly amateur-hour radio show, and staged variety shows. Every Thursday, they brought their dance students and performers to the Carew Tower to perform in front of the camera. Their involvement in television continued for decades. (Courtesy Cincinnati Post.)

In 1942, at age 13, Bob Braun made his broadcast debut hosting a Knothole Baseball show on WSAI radio. Three years later, Braun (right, singing "Sonny Boy" with Tom Miller) sang in amateur shows produced by Harris Rosedale and presented in theaters between movies. Braun made his television debut in 1947, singing on Rosedale's variety show for Crosley Corporation's experimental W8XCT, six months before the birth of commercial television. (Courtesy the Braun collection.)

In addition to radio broadcasts from his Camp Washington facility, Powel Crosley invented and manufactured an electronic explosive detonator during World War II. The government did not want radio facilities near this highly classified work, so the Crosley Radio Corporation bought the Elks temple at Ninth and Elm Streets in 1942. WLW radio and, years later, WLW-T set up operations there. Television remained there until June 1999, when it moved to Mount Auburn.

The first television show produced at Crosley Square at Ninth and Elm Streets was *The Pogue Style Show.* This look at fashions available at the popular Cincinnati department store aired on W8XCT on November 13, 1947, before the completion of the studios on Mount Olympus. (Courtesy WLWT.)

The Saratoga Bar in Corryville provided the first television set publicly on view for customers. Owner Louis Lauch mounted the seven-inch model above the bar, and business increased more than 30 percent. Since so few people had television sets when WLW-T signed on in 1948, many greater Cincinnati bars and restaurants advertised that their customers could experience this new phenomenon in their establishments.

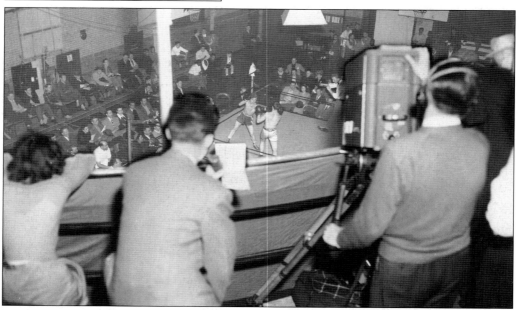

WLW-T was scheduled to sign on February 9, 1948, but the Cincinnati Golden Gloves competition began one week earlier. Boxing fans loved the bouts presented during the experimental broadcasts and did not want to miss the first round waiting for the commercial era to begin. The George Wiedemann Brewing Company became the first television advertiser in Cincinnati, sponsoring matches that aired on February 2, 1948. (Courtesy Cincinnati Museum Center.)

The Television Center at 608 Race Street advertised Crosley television sets in the Saturday, February 14, 1948, *Cincinnati Post* to celebrate the launch of commercial broadcasting. Since early programming was presented only a few hours each day, the advertisement encouraged the public to visit the downtown store during the 4 hours and 15 minutes that WLW-T was actually broadcasting that day.

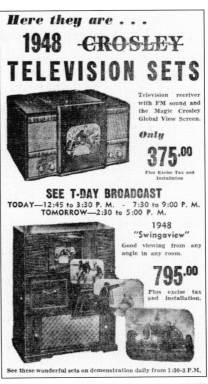

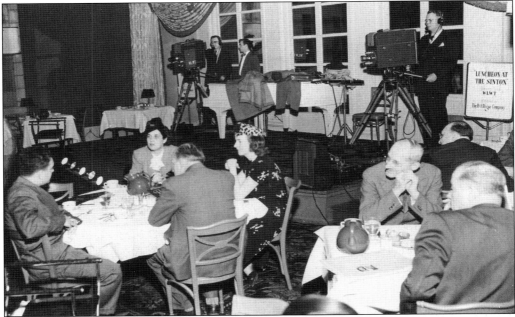

On the first day of regular commercial operation of WLW-T, the first sponsored program of the day, *Luncheon at the Sinton*, was scheduled to begin at 12:30 p.m. from Fourth Street in downtown Cincinnati. It actually began five minutes late. Operating the cameras were Ed Gleason, (right) and Bill Augenbaugh. (Courtesy WLWT.)

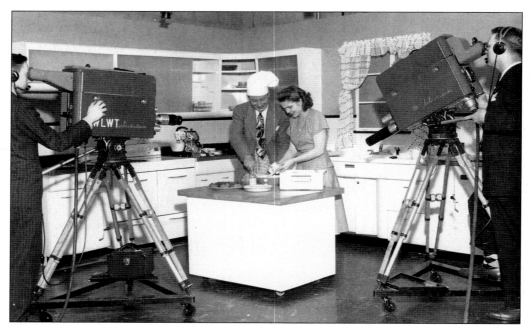

The Kitchen Klub, starring Miss Beck, was the second sponsored television show presented on WLW-T's first day of commercial broadcasting. It was to air from 3:00 p.m. to 3:30 p.m. but, due to lack of rehearsal time, the meal was not completed in 30 minutes, so the show ran until 3:40 p.m. (Courtesy WLWT.)

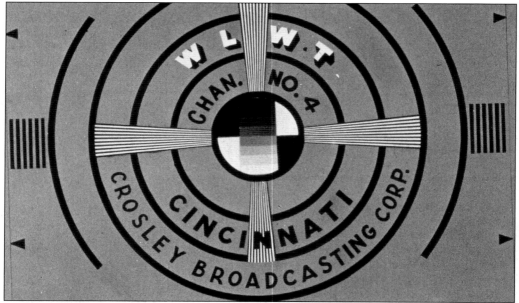

Control room engineers used test patterns to calibrate, align, and match studio cameras before each broadcast. Test patterns were also transmitted before and after programming. This pre-1952 WLW-T test pattern ran weekdays from noon until 2:00 p.m. and from 3:30 p.m. until 5:00 p.m. Test patterns were presented with a background of original music, a tone, or the radio broadcast of the station owned by the same broadcaster. (Courtesy Bill Myers.)

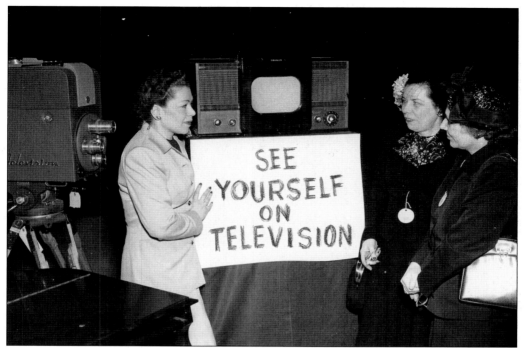

On Monday, April 19, 1948, two months after the official WLW-T sign-on, 7,600 people visited Mount Olympus, the home of WLW-T in Clifton Heights. They watched the Cincinnati Reds opening day game on television and the premiere of *Midwestern Hayride*. In order to promote the early sale of television sets, visitors were given the chance to see themselves on television. WLW-T sports anchor Red Thornburgh (below, center) talks with a television expert about the different television receivers available on the market. (Courtesy WLWT.)

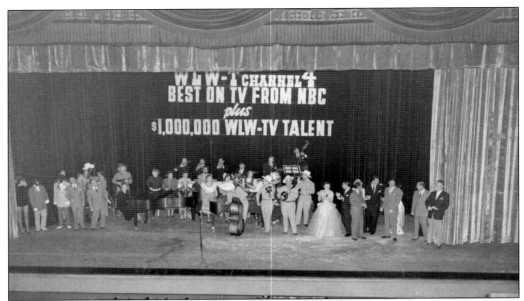

By 1949, WLW-T had almost 100 stars appearing daily on Channel 4–originated programs. They were promoted as the greatest collection of radio-television personalities outside New York and Chicago. On September 22, 1949, WLW-T presented its "Million Dollar Talent" to a sold-out crowd at the Taft Theater, a frequently used location from which to telecast station personalities. Many of the *Midwestern Hayride* stars stand center stage. (Courtesy WLWT.)

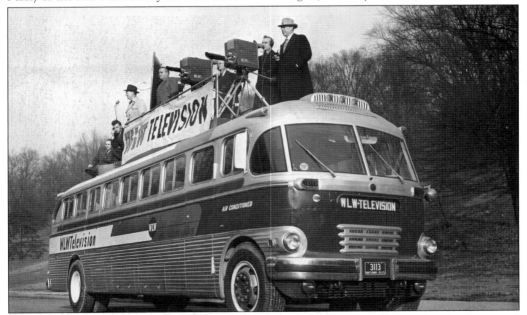

One great promise of television was that Cincinnati viewers would get to see events and performances around the city while at home. WLW-T's mobile unit was used to broadcast the first locally televised baseball game on September 21, 1947, between the Cincinnati Reds and the Philadelphia Phillies. Its first televised football game was on October 11, 1947, between the University of Cincinnati and the University of Dayton.

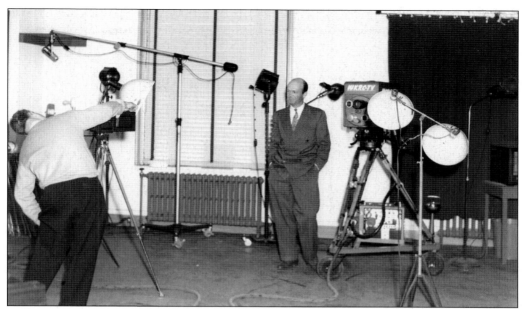

Hulbert Taft Jr. entered the broadcast business in 1939, when his father, publisher of the *Cincinnati Times-Star*, bought WKRC-AM from CBS for $200,000. The original WKRC-TV studios were in the *Cincinnati Times-Star* building at Eighth Street and Broadway. WKRC-TV's weak signal made reception difficult until the early 1960s, when it built the 967-foot tower in Mount Auburn, earning the nickname "Tall 12." (Courtesy Cincinnati Museum Center.)

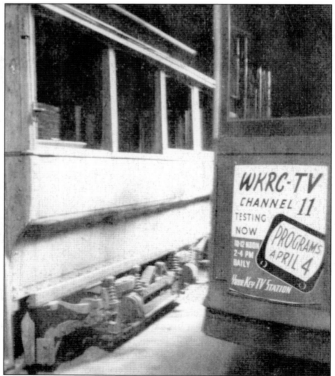

Early in 1949, Taft Broadcasting promoted the coming of Cincinnati's second commercial television station on the backs of streetcars. The four hours of daily testing prior to the April 4th sign-on was designed to train technical staff, test equipment, experiment with programming, and build an audience before becoming a commercial entity. (Photograph by Bill Myers.)

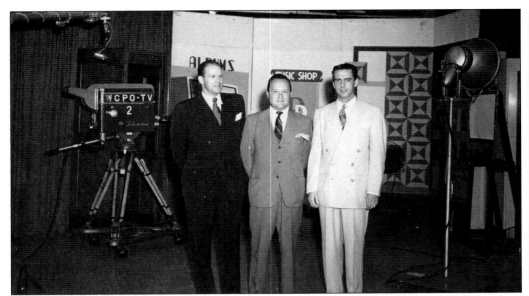

When WCPO-TV signed on, WLW-T and WKRC-TV were broadcasting only four hours each day. Scripps-Howard Broadcasting vice president Mortimer C. Watters (right), who is pictured with Charles Scripps (left) and Jack Howard, said, "I don't care if it's a guy reading the phone book, I want something on whenever someone tunes in." Watters also wanted local personalities. He discovered Cincinnati legends Al Schottelkotte, "Uncle Al" Lewis, Paul Dixon, Skipper Ryle, and others.

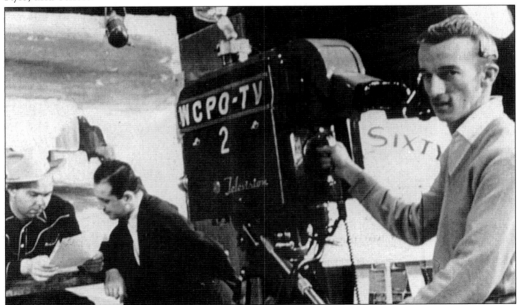

It was noon on Tuesday, July 26, 1949, when WCPO-TV signed on the air. The first image was a logo for *Midday Merry-Go-Round*, with the Bluegrass Ramblers playing in the background. Announcer Dick Woods said, "And now, here's Big Jim Stacey!" Then the first person ever to appear on WCPO-TV stood, smiling in his cowboy hat, and said, "Howdy, friends and neighbors, and welcome to the very first *Midday Merry-Go-Round*." (Courtesy WCPO.)

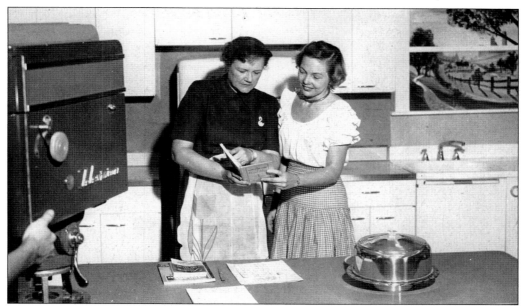

The second WCPO-TV program to air on the first day was *Women's TV World*, hosted by Penny Pruden (left). As the station's cooking expert, Pruden's daily show presented cooking hints and advice from her Hotpoint model kitchen. Later WCPO-TV would present other household programs, including *Garnet Grayson Suggests*, *The Kitchen Show* with Norma Antenucci, and *Continental Cookery* with Stanley Demos. (Courtesy WCPO.)

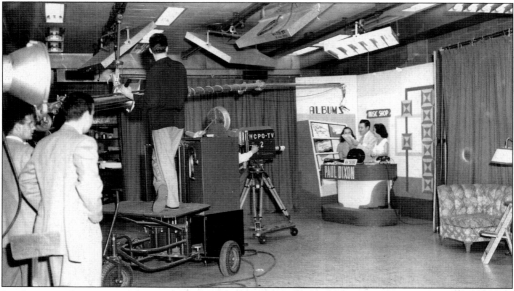

Paul Dixon, born Gregory Schleier, began his career as a radio disc jockey in Chicago before joining WCPO radio in 1945. He was named Cincinnati's best newscaster in 1947 but preferred entertainment to news. So in WCPO-TV's third hour of broadcasting on the first day, Cincinnati's most popular disc jockey launched his three-hour *Paul Dixon's Music Shop*, also featuring Dotty Mack and Wanda Lewis, pantomiming records and clowning with his costars. (Courtesy WCPO.)

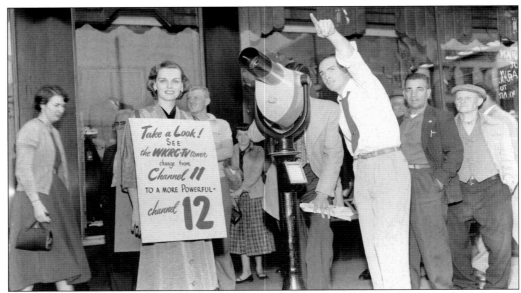

In September 1948, the Federal Communications Commission (FCC) began to study the effects of increased station power and channel assignments. Homes too far from television towers received fuzzy images or no picture at all. Viewers between cities often saw simultaneous images from two television stations. In 1952, WKRC-TV moved from Channel 11 to 12, and in 1953, WCPO-TV and WLW-T moved from Channels 7 and 4, respectively, to Channels 9 and 5. (Courtesy Cincinnati Museum Center.)

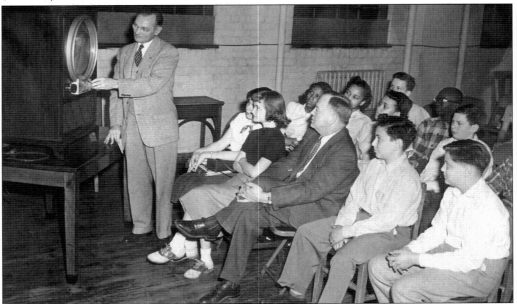

Russell Helmick, principal of Holmes High School in Covington, won a grant to study the possible use of television in the classroom a few years before WCET signed on. Students from Walnut Hills, seen here with Helmick (standing), joined students from 13 local high schools to watch a series of programs called *Look Learning*. Helmick's goal was to determine whether teachers thought classroom television was a good idea. (Courtesy Cincinnati Post.)

Crosley Broadcasting built its transmitter, tower, control room, and studio on the southern Fairview Heights cliff overlooking downtown and called it Mount Olympus. While still the site of the WLW-T tower, Mount Olympus later was leased to WCET for $1 per year to house its studio and transmitter. It also has been the home of commercial and programming production units. (Courtesy WLWT.)

In the early days of television, most programs were live. The only way to make a copy of the live program was to film the television screen with a motion picture camera, an expensive process known as kinescope. Videotape was invented in the 1950s by Ampex, whose engineers visited Mount Olympus to show their invention to Cincinnati broadcasters. The demonstrated Quadruplex machines were first used in television stations in 1956. (Courtesy WLWT.)

UHF-48

TELEVISION IS A POWERFU

watch it more hours than the
to enrich our lives, to extend
trivial and merely diverting

There
Cincin
within

Yes, t
influe
we ha
somet.

EDU
. . . t
can g
which
. . . in

SCHOOL

HOME

BEHIND THE SCREEN

. . . is a group of far-sighted citizens . . . the FCC has reserved
Channel UHF 48 here for educational purposes . . .
Mr. James Shouse has granted permission to use the WLW tower
which will save the cost of building a tower — $150,000
. . . the College of Music will permit the use of their television
equipment and studio in which their investment is $80,000 . . .

IF WE RAISE $
CAN EXPECT FF
FOUNDATION, B
SUPPORT OF O

We now have capi
Use of WLW
Music studio an

Cash or pledges
deposit with ap

Cash and pledges n

A TENTATIVE BUDGET
FOR COMPLETION OF STATION AND TWO YEARS' OPERATION
LOOKS LIKE THIS

On April 14, 1952, the FCC approved the use of ultra high frequency (UHF) Channels 14 through 83, opening the way for Cincinnati's fourth television station. When WCET telecast a program called *Tell-A-Story* on July 26, 1954, only about 500 television sets in Cincinnati were equipped to receive the UHF signal of the first licensed public television station in the United States. The original studios were in the attic of the Music Hall, and students from the College of Music's Radio-Television Arts Department operated the equipment. Uberto T. Neely was founder and director of the department. It was significantly through his efforts that WCET came into existence. He served as WCET's first general manager. During the 1950s, WCET produced more than 100 programs for national distribution plus high school and college television courses and high school football games. (Courtesy Cincinnati Museum Center.)

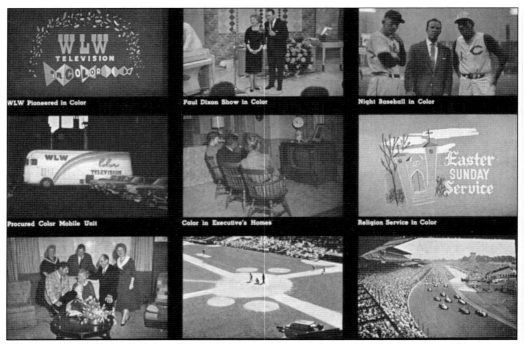

WLW Pioneered in Color Paul Dixon Show in Color Night Baseball in Color

Procured Color Mobile Unit Color in Executive's Homes Religion Service in Color

On January 1, 1954, NBC broadcast the Tournament of Roses Parade in color to 21 stations, including WLW-T. There were only 200 color television sets in the United States at that time. In August 1957, Ruth Lyons's *50-50 Club* became the first local live show telecast in color. By 1960, five percent of Cincinnati households had color television sets and 30 percent of WLW-T programming was in color, earning Cincinnati the title "Colortown, U.S.A." (Courtesy WLWT.)

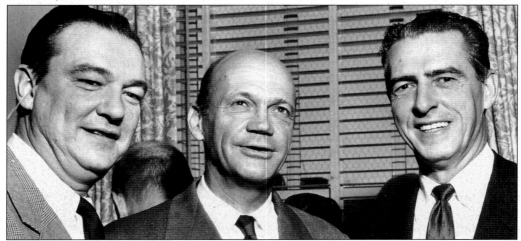

In 1950, John T. Murphy (left), vice president and general manager of Crosley Broadcasting's WLW-T, joined Hulbert Taft Jr. (center) of Taft Broadcasting's WKRC-TV and Mortimer C. Watters of Scripps-Howard's WCPO-TV. Cincinnati's television stations were owned by local companies and run by three men who were great competitors. Their philosophy was "live and local." They gave viewers such legendary programs as *Midwestern Hayride*, *The Skipper Ryle Show*, and *The Paul Dixon Show*.

In the mid-1950s, WLW-T moved its news and weather departments across the street to the Comex (Communications Exchange) building at the northwest corner of Ninth and Elm Streets. This left the Crosley Square studios for Ruth Lyons, *Midwestern Hayride*, and other live shows. Comex also housed a WLW radio control room and studio, which was visible through street-level windows where Cincinnatians could watch their favorite television news or radio personalities. (Courtesy WLWT.)

For more than 30 years, viewers looked to *Cincinnati Post* columnist Mary Wood for behind-the-scenes and on-the-screen Cincinnati television information. Wood (left), seen here interviewing WCPO-TV's Paula Jane, was the *Cincinnati Post*'s radio reporter in 1946; her job expanded to cover television as the stations signed on and the medium grew. Her columns followed the growth of television until her retirement in 1978.

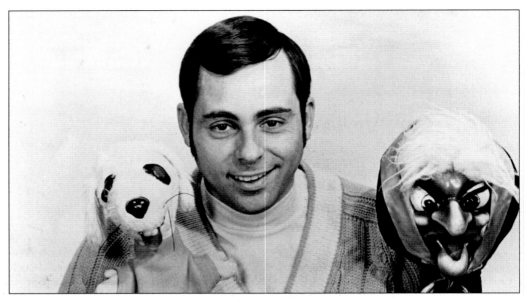

WXIX Channel 19 signed on as Cincinnati's fifth television station on Thursday, August 1, 1968. Before the inaugural broadcast, station engineers aired their test pattern and "mini-shows," featuring the Larry Smith Puppets promoting the sale of UHF converters needed to watch Channel 19 on pre-1964 television sets. After Larry Smith and his puppets participated in the inaugural broadcast, he hosted a children's program on weekday afternoons for several years.

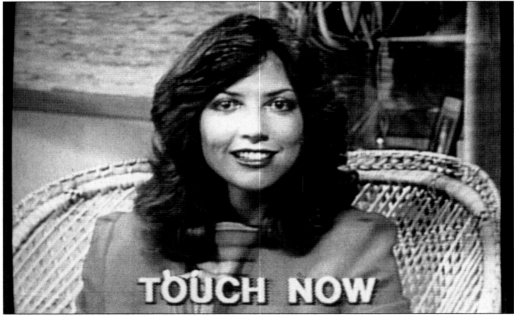

In the early days of Cincinnati cable television, Laura Skylar involved viewers in interactive polls on *Soap Scoop*, her local access review of network soap operas. Viewers voted by using interactive software, known as "Qube," which Warner Cable debuted in 1977. Warner dropped Qube in 1984, citing program production cost concerns. Skylar left Warner Cable to host *PM Magazine* from 1982 to 1984 using her real name, Laura Soller.

Two

LET'S TALK

From 1927 to 1956, radio talk shows accounted for a quarter of all radio programming. So it was only natural that television would use the hosts of these shows to move faithful radio listeners to television. This may be why most viewers perceived the new medium to be radio, with pictures.

The "first lady" of Cincinnati television talk was born Ruth Reeves in 1905 in the East End. Always musically talented, Ruth was hired as a pianist and assistant music director at WKRC radio. In May 1929, the host of *The Woman's Hour* was sick and Ruth was sent to the studio to fill in. The sponsor loved her comfortable, improvisational style and asked her to take over the show.

Ruth married and subsequently divorced Johnny Lyons, keeping only his name as her loyal radio listenership grew. In 1942, Crosley Broadcasting Corporation lured her to WSAI and WLW with a $10 a week raise. There Ruth hosted popular programs such as *Morning Matinee*, *Petticoat Partyline*, and *Consumer's Foundation*.

In 1945, she approached her bosses with an idea for a mid-day program to be broadcast live from the Hotel Gibson downtown. Her idea was to invite 50 women each day to pay $1 for lunch and remain for her radio show. The *Fifty Club* debuted February 5, 1946. While still broadcasting on radio, WLW added a 90-minute television simulcast in 1949. The television studio had room for 100 people, prompting a name change to the *50-50 Club*.

The king of Cincinnati talk television was Paul Dixon. Dixon had been one of Cincinnati's top radio disc jockeys. He could not sing. He could not dance. He was not a good actor. What he could do was talk. He loved his audience, and they loved their "Paul Baby."

Dixon was predictable. He opened every show with, "This has got to be the youngest and most beautiful bunch of women we've ever had on this show!" He was also unpredictable. His most famous show was the wedding of two rubber chickens. Dixon was a major influence on many modern talk show hosts, most notably David Letterman. Many Cincinnati television talkers followed in the footsteps of Ruth and Dixon, including Bob Braun, Nick Clooney, Wirt Cain, Dennis Wholey, Irma Lazarus, Ira Joe Fisher, and Jerry Springer.

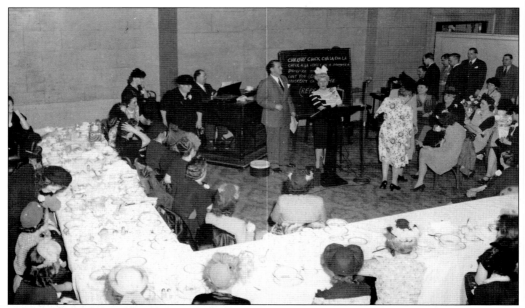

Television was two years away from signing on when this picture was taken on February 5, 1946, but this event changed the direction of television history. Ruth Lyons had already been a hit on WSAI and WLW radio shows *Morning Matinee, Petticoat Partyline,* and *Consumer's Foundation.* Here Lyons presides over her new show, the first *Fifty Club* luncheon and radio program at the Hotel Gibson. (Courtesy WLWT.)

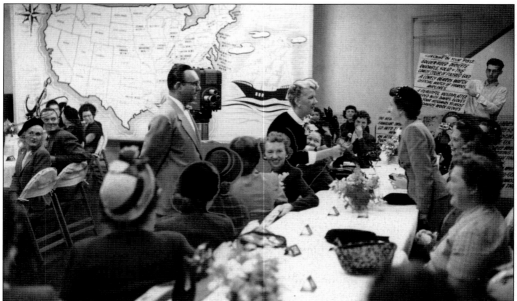

Lyons was one of the first to turn the camera on the audience so that viewers could see their friends and neighbors on television. Lyons (holding microphone) talks to a visitor with cohost Willie Thall standing behind her, during a show in the summer of 1951. Lyons had many cohosts during her 18 years on the *50-50 Club,* including Paul Jones, Peter Grant, and Bob Braun. (Courtesy Cincinnati Post.)

Fans waited for hours in lines that stretched around Columbus's Veterans Memorial Hall for a 1966 live broadcast of the *50-50 Club*. It was not unusual to see fans lined up for blocks outside of theaters when Lyons took her show on the road. Tickets to her studio program sold out three to five years in advance. (Courtesy WLWT.)

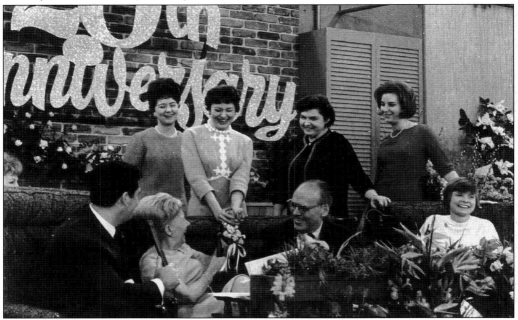

Viewers of the *50-50 Club* knew Lyons's office staff as well as those in front of the camera. Behind the couch, from left to right, are Mickey Fisher, Elsa Sule, Gloria Rush, and Andrea Sams. They were her family of secretaries. Lyons often received more than 1,000 fan letters each week, and her small staff answered each one with a personal letter. (Courtesy Michael Jaggers.)

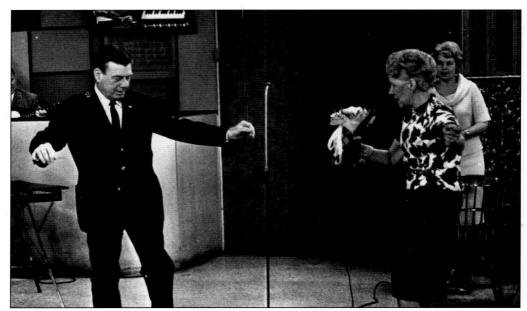

The one rule for guests on the *50-50 Club* was that performers must perform. Here Ruth Lyons dances with CBS television star Arthur Godfrey while Ruby Wright watches. For more than 20 years, the greatest movie stars, television personalities, musicians, politicians, comedians, and news makers traveled to Crosley Square to share the *50-50 Club* couch with Lyons. (Courtesy Michael Jaggers.)

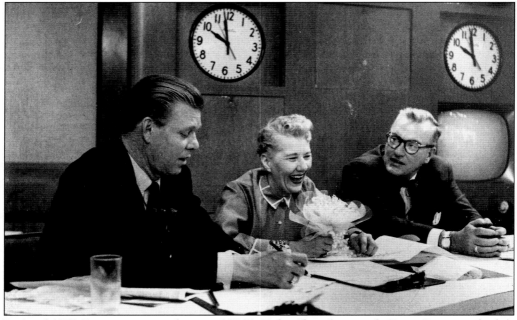

In April 1958, Lyons was invited to join NBC's *Today Show* for a week. Dave Garroway (right), Jack Lescoulie, and their crew tried to make Lyons feel at home with her traditional flowered microphone. When Lyons returned home she told viewers she much preferred the spontaneous conversation and ad-libbing of the *50-50 Club*. (Courtesy WLWT.)

In August 1944, Lyons's daughter was stillborn. She and husband, Herman Newman, adopted a baby who was born two days before their own. Candy (center), with Lyons and Willie Thall, literally grew up on the *50-50 Club*. Lyons was affectionately called "Mother" because of the way she mothered Candy, her cast, crew, and everyone she met. (Courtesy Michael Jaggers.)

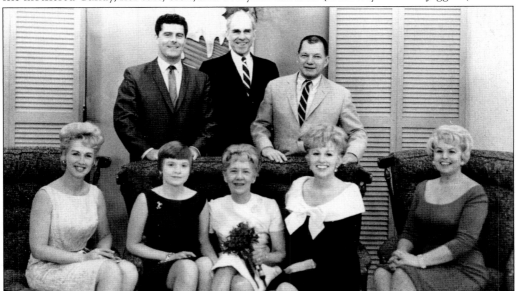

The 1965 family, from left to right, is (first row) Bonnie Lou, Candy, Lyons, Marian Spelman, and Ruby Wright; (second row) Bob Braun, Peter Grant, and Cliff Lash. In June 1966, Candy lost her battle with breast cancer. After a leave of absence from the show, Lyons made an emotional return, but her grief made it impossible for her to continue. On January 27, 1967, Avco vice president Walter Bartlett appeared on the *50-50 Club* and announced that Lyons had retired. She never appeared on camera again. She died in 1988. (Courtesy WLWT.)

Paul Dixon started on WCPO radio in 1945. By the time WCPO-TV signed on in 1949, Dixon was its biggest star. There was one major difference between Dixon of Channel 7 and Dixon of Channel 5—the audience. On *Paul Dixon's Song Shop,* his audience was the camera crew. His show on WCPO made him a star. His rapport with the studio audience on WLW-T made him a legend. (Courtesy WCPO.)

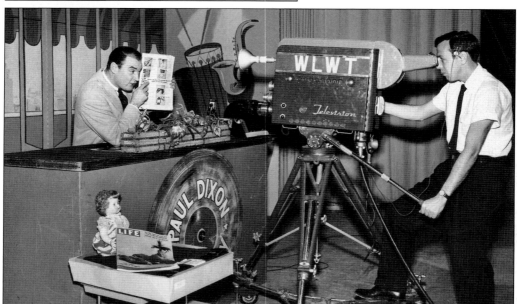

By 1954, Dixon's three-hour daily pantomime talk show was so popular that the Dumont Network convinced Dixon to move to New York and broadcast the show nationally. Homesick for Cincinnati, Dixon returned less than a year later, but not to WCPO. At WLW-T, he created a morning show that ran from 9:00 a.m. to 10:30 a.m. and was geared toward an adult audience. Charlie Blu is the cameraman. (Courtesy WLWT.)

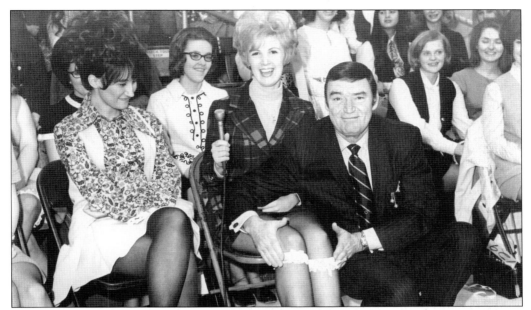

Fans of *The Paul Dixon Show* looked forward to his trademark antics. At the beginning of every show, Dixon would use binoculars to scan the front row of his audience, known as "Kneesville." Next asking how many took a bath that morning, he would spray the audience with water, then award the best-looking knees with a garter or "knee-tickler," a dangling earring he attached to the hem of the winner's skirt. (Courtesy WLWT.)

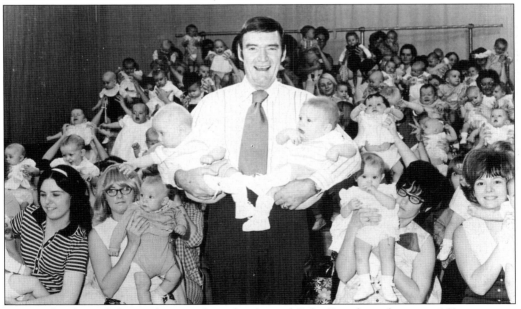

Dixon often hosted theme shows such as the Annual Baby Day show, featuring 160 screaming infants, their mothers, and a lot of Pampers. Dixon also presided over Hot Pants Day, Tall Girls Day, Come As You Are Day, and Fat is Beautiful Day. Dixon, the king of double entendre, gave away daily Oscherwitz Kosher salamis, which David Letterman says inspired his canned ham give away. (Courtesy WLWT.)

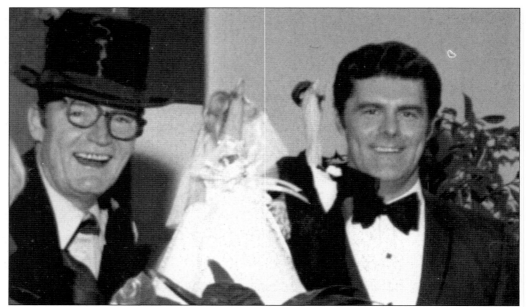

On Tuesday, March 11, 1969, Paul Dixon staged the wedding of Henrietta Pauline Leghorne and Harold (Harry) Dominic, two rubber chickens that had been longtime show props. Dixon (left) officiated as mayor of Kneesville, dressed in a tattered coat and matching top hat. Bob Braun was Harry's best man. This was the highest-rated episode in the show's history. Viewers stayed home from work and school to watch the chicken wedding live. (Courtesy Michael Jaggers.)

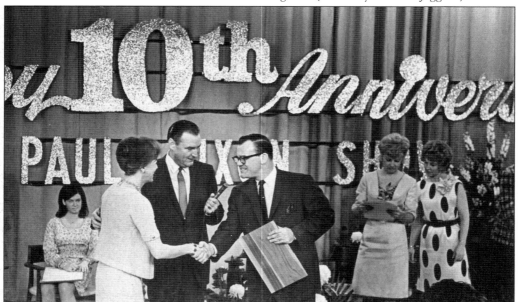

In 1965, Dixon celebrated his 10th anniversary on Channel 5 with, from left to right, his daughter Pam; wife, Marge; WLW-T vice president Walter Bartlett; Marian Spelman; and Bonnie Lou. The 1970 death of his son Greg led to Dixon's first heart attack. He never fully recovered. Dixon died on December 28, 1974. After a month of reruns, Channel 5 concluded that Dixon could not be replaced and quietly ended *The Paul Dixon Show*. (Courtesy WLWT.)

36

WCPO-TV hired Bob Braun in October 1949, three months after the station signed on. He ran cameras, hosted an early-morning exercise show, read to kids on his own *Uncle Bob Reads the Sunday Comics*, sang on *Bride-to-Be*, and hosted a two-hour Sunday morning show called *Audition Time*. He also sang and greeted housewives daily on *Meet the Ladies* (above), an audience participation show from Penny Pruden's Pantry at Peebles Corner. (Courtesy the Braun collection.)

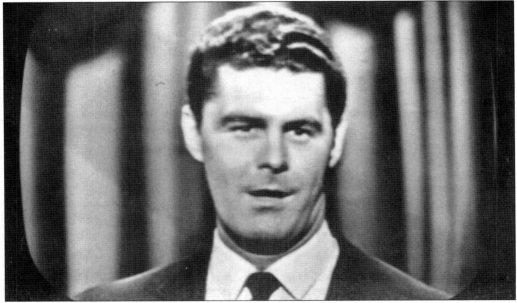

Braun pantomimed songs on WCPO-TV's *Dotty Mack Show* from 1953 to 1956. But his big break came on January 14, 1957. Pictured here, Braun won the $1,000 first prize singing on Arthur Godfrey's *Talent Scouts* on CBS. Even before he returned to Cincinnati from his New York appearance, WLW-T program director Abe Cowen called Braun and offered him a job. On February 9, Braun moved to Channel 5. (Courtesy Dennis Hasty.)

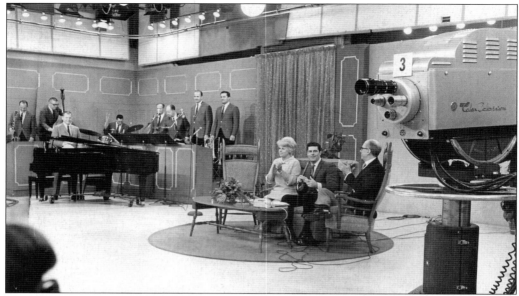

At WLW-T, Bob Braun appeared on many shows, including hosting his own early-evening musical program, emceeing late-night movies, and being a regular on the *50-50 Club*. He was also a popular voice on WLW radio. When Ruth Lyons retired in early 1967, Braun inherited the popular noon program. Braun, pictured at center with the microphone, sits between Peter Grant and Ruby Wright, with Cliff Lash standing at the piano. (Courtesy WLWT.)

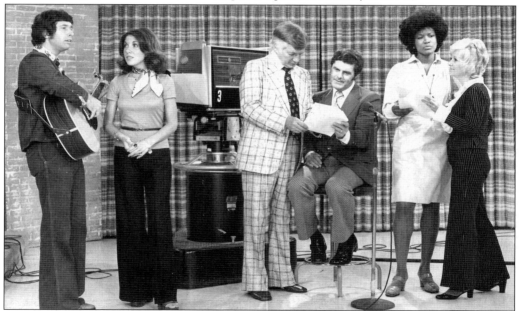

In the mid-1970s, the *Bob Braun Show* added younger performers. The 1975 cast included Rob Reider (left, with guitar), Nancy James, Cliff Lash, Braun, Gwen Conley, and Colleen Sharp. In 1984, after keeping the show on the air for nearly 18 years, the shrinking number of homemakers, an aging audience, higher production costs, and fewer national guests forced Channel 5 to cancel it. (Courtesy WLWT.)

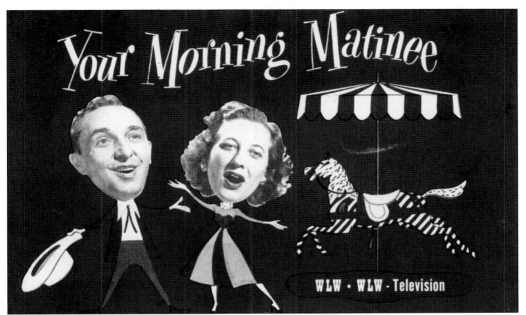

Ruth Lyons created *Morning Matinee* as a radio show in the 1940s and moved it to television. In 1952, Lyons turned *Morning Matinee* over to Judy Perkins, who was also on *Midwestern Hayride*. WLW-T sent this annual cartoon calendar of Perkins and cohost Ernie Lee to fans who remember their *Morning Matinee* musical greeting, "Judy Perkins and Colonel Ernie Lee, friends to greet you, just you wait and see."

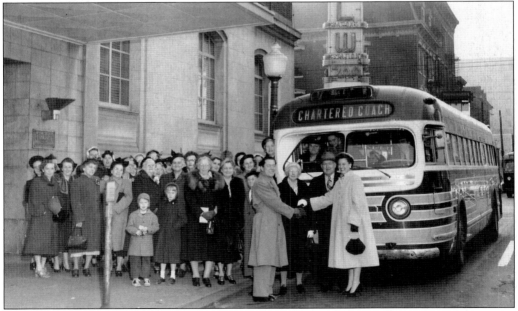

By the early 1950s, more than 60,000 visitors a year were traveling to Crosley Square in downtown Cincinnati to attend one of WLW-T's live audience programs, such as Ruth Lyons's *50-50 Club*, *The Paul Dixon Show*, and *Midwestern Hayride*. On February 20, 1954, Judy Perkins and new cohost Russ Brown greet a chartered bus carrying another group visiting *Morning Matinee*.

A "BRANDS YOU KNOW" COUPON

Ruth Lyons... recommends
TETLEY TEA
on "50-50 Club"
WLW—Television

Advertisers loved any association with Ruth Lyons, whether advertising on her show or gaining her product endorsement. One day Lyons mentioned the brand of perfume she wore. It sold out in Cincinnati, Dayton, and Columbus in three days. A contest for Kroger's bread drew 165,851 entries, and after 10 weeks of exposure on her show, a brand of canned vegetables went from Cincinnati's seventh most popular to number one. (Courtesy Dennis Hasty.)

Othur Oliver ran the "loot room" at WLW-T. It was his responsibility to collect prize giveaways for television and radio shows. Oliver determined which items to accept and which to reject from manufacturers who bid for placement on Ruth Lyons's *50-50 Club*, *Morning Matinee*, *Quiz the Missus*, and *Breakfast Party*. (Courtesy Cincinnati Post.)

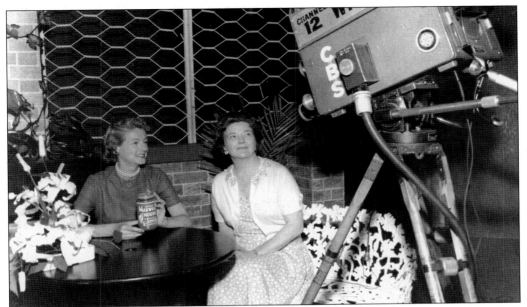

Jane Lynn Faulkner, shown here promoting Maxwell House coffee, was known simply as Jane Lynn when she appeared on WKRC-TV's early talk shows for homemakers. Later she appeared on the Channel 12 news with George Palmer, WLW-T's *Pic-a-Pac of Prizes* giveaway show with Dick Hageman, and in many filmed commercials produced at Mount Olympus by Crosley Broadcasting's Olympus Films division. (Courtesy Cincinnati Museum Center.)

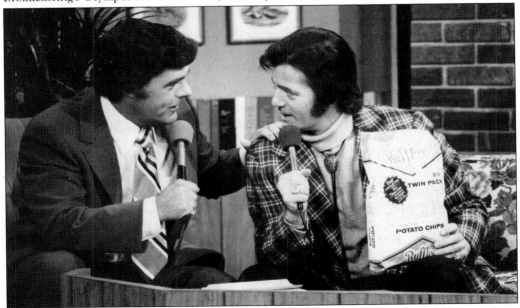

Bob Braun was one of Cincinnati television's greatest pitchmen. On his show, selling products was part of the entertainment as Braun (left) encourages Robert Goulet to become a local pitchman for Grippo's. After leaving WLWT in 1984, Braun anchored on the J. C. Penny Shopping Channel and was spokesman for Craftmatic adjustable beds and other infomercials and commercials. (Courtesy WLWT.)

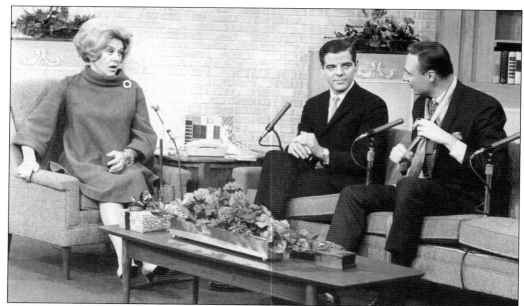

After guest hosting the *50-50 Club* and *The Paul Dixon Show*, Vivienne Della Chiesa became the host of *The Afternoon Show* weekdays at 4:00 p.m. on WLW-T in 1967. The former star of New York's Metropolitan Opera was joined by cohost Nick Clooney. When *The Afternoon Show* was cancelled in 1969, 16,000 signatures were delivered to the station unsuccessfully begging to keep the show on the air. (Courtesy WLWT.)

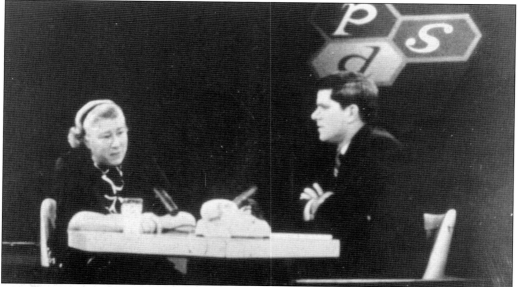

On November 6, 1967, atheist Madalyn Murray O'Hair (left) appeared on the first *Phil Donahue Show*, beginning a new era of talk television. Although Donahue's show was produced in Dayton, it was WLW-T's parent company, Avco Broadcasting, and Cincinnatian Don Dahlman that convinced Donahue to originate his show from WLW-D. The original *Phil Donahue Show* aired only on Avco stations, including WLW-T, before being syndicated nationally in 1970. (Courtesy Phil Donahue.)

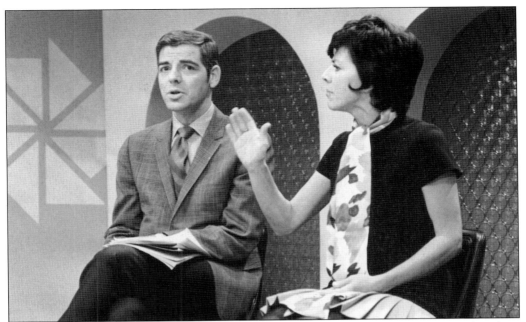

The Nick Clooney Show aired at noon daily from 1969 until 1972 on WCPO-TV with cohost Wirt Cain. Cancelled by Channel 9, Clooney moved to Channel 12 from 1972 to 1975 with cohost Glenn Ryle. Clooney sang and talked with guests, including his sisters Betty (pictured) and Rosemary. Clooney's show attracted a younger audience than other Cincinnati talk shows by dealing with more serious guests and issues. (Courtesy Nick Clooney.)

WCET added a talk show to Cincinnati's airwaves with *Conversations with Irma*. The show was created and produced by Len Goorian (standing) and starred Cincinnati arts patron Irma Lazarus. During her 20 years on Channel 48, *Conversations with Irma* exposed Cincinnati to the arts, allowing Lazarus to share her close friendships with world-famous figures such as conductor Leonard Bernstein and opera star Beverly Sills. (Courtesy the Cincinnati Post.)

Ira Joe Fisher (left) shared his unique brand of humor as Channel 12 weatherman and *PM Magazine* host from 1980 to 1983 before moving to New York. He returned to WKRC-TV to host his daily talk and variety program, *The Ira Joe Fisher Show,* from 1986 to 1989. Cohost Joyce Wise, guests, and a studio audience in Channel 12's Mount Auburn studios joined him weekday mornings at 9:00. Nick Clooney (right) appeared on the first show.

In 1989, *The Ira Joe Fisher Show* finished its three-year run, ending the daytime live-audience show tradition that began with Ruth Lyons. More syndicated talk shows, fewer daytime viewers with more choices, and shrinking budgets were the causes. In 1987, Fisher (left) invited some of Cincinnati television's greatest to reminisce about the history of Cincinnati television: Glenn "Skipper" Ryle, Bob Shreve, Wanda "Captain Windy" Lewis, and Uncle Al Lewis. (Courtesy Bill Renken.)

Three

"EEEEE-LEVENNNN O'CLOCK"

Cincinnati did not know him by the name his parents gave him. He was born Melvin Meredith Maginn in St. Louis on December 13, 1906. But Maginn would become the most important name in Cincinnati radio news with his chosen name, Peter Grant. He began in radio in 1932, reporting the news six nights each week on "the Nation's Station." It was only natural that Grant would also anchor the news when WLW-T signed on. For more than a decade, he defined television news in Cincinnati.

By 1959, WCPO-TV had been on the air for 10 years and had no news presence. General manager Mortimer C. Watters wanted a newsman but could not find one. There was a man doing the 6:00 p.m. newscast on WSAI radio and writing a column for the *Cincinnati Enquirer*. His name was Al Schottelkotte. Watters did not like Schottelkotte, explaining that "he used to write nasty things about me." But Watters liked Schottelkotte's commanding presence. The other newsmen read from a script and it sounded like it. Schottelkotte was different.

Watters contacted Schottelkotte and offered him the top newscaster job. Schottelkotte quickly accepted, then asked when he could start. Watters responded, "Tonight," adding, "Don't worry about the audience - you won't have one." In 1961, two years after starting the news department, the *Al Schottelkotte News* moved into first place ahead of Channel 5's Peter Grant and Channel 12's George Palmer. It stayed in first place for the next 22 years.

The *Al Schottelkotte News* was like no other. Schottelkotte voiced all stories. There were no reporter packages. There were always full-screen pictures, whether Polaroids, wirephotos, or film footage. This was the news Ted Turner remembered while growing up in Cincinnati. It became the model for his CNN Headline News Channel.

In 1984, Nick Clooney's WKRC-TV news ended Schottelkotte's 22-year reign. Since the end of the Schottelkotte era, there have been many news teams, including Jerry and Norma, Clyde and Carol, and Rob and Kit. But the history of Cincinnati television news still can be summed up in eleven words—"Eeeee-levennnn o'clock in the Tri-State, time for the Al Schottelkotte News."

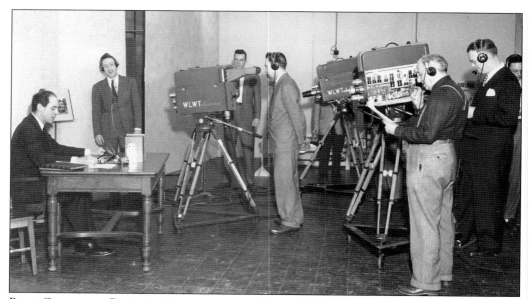

Peter Grant was Cincinnati's most respected broadcast journalist for more than 30 years, beginning at WLW radio in 1932. Because WLW's signal reached across the country, he earned a national reputation by the time he began delivering the news on television in 1948. Grant (seated, left) reads the news on WLW-T's first newscast in 1948. The crew, pictured from left to right, are unidentified, unidentified, Don Smith, Charlie Lammers, Ed Gleason, and Gene Walz. (Courtesy WLWT.)

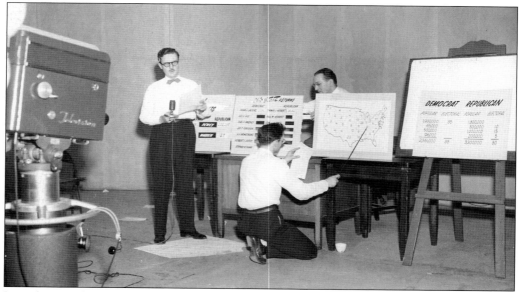

It took 28 WLW-T staffers to produce the first televised presidential election coverage in Cincinnati history on November 3, 1948. Announcer Hal Woodard reads state-by-state returns while Gene Walz points to corresponding states on the electoral-vote map. Artist Rudy Prihoda (center) chalks up the latest popular vote totals. Part of the program originated from Hamilton County's Board of Elections offices where another announcer-technician-artist crew was on duty. (Courtesy WLWT.)

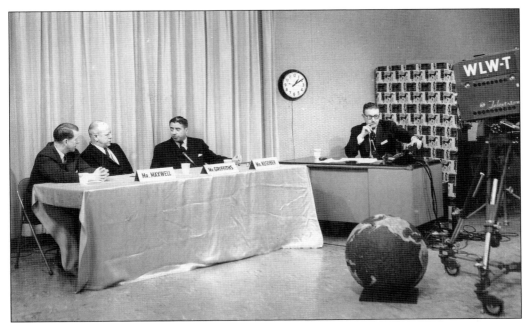

World Front began as a radio program on Sunday, December 7, 1941, as a spontaneous newscast to report on Pearl Harbor. It moved to television with host Howard Chamberlain moderating panel discussions about current events every other Sunday at 1:00 p.m. This episode from January 18, 1959, was titled "Which Way for France?" (Courtesy WLWT.)

George Palmer joined WKRC-TV in 1949, and in 1952, he was named news director. He was Channel 12's main news anchor for more than a decade. Here preparing for the late evening news in the mid-1950s, Palmer looks at an early version of the teleprompter that was operated by floor director Ted Bushelman. Bushelman then spent more than 40 years as senior director of the communications department at the Cincinnati-Northern Kentucky International Airport. (Courtesy Cincinnati Museum Center.)

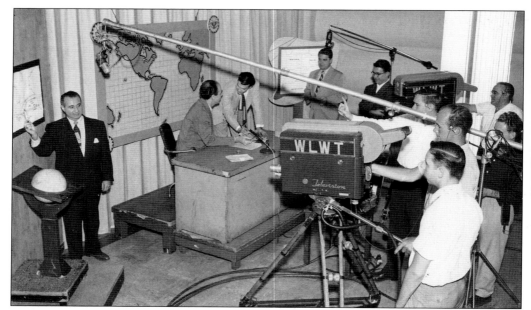

In this 1951 newscast, reporter Milton Chase updates the Korean conflict while director Bob Gilbert talks with Peter Grant. The weatherman standing by the map is Lou Morton. WLW-T's evening news was called *Three City Final* because it also was seen on WLW-D in Dayton and WLW-C in Columbus. In December 1957, *Three City Final* ended and the WLW-T news became totally local.

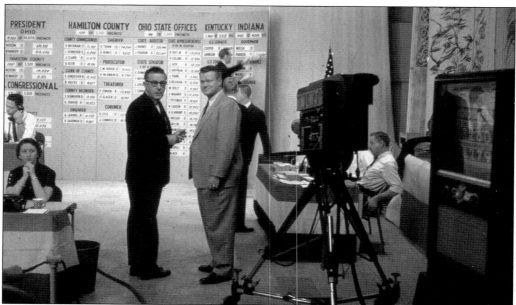

Things changed in the 12 years since WLW-T presented the first televised presidential election results. WLW-T newsman Howard Chamberlain, who is pictured standing, wearing glasses, with producer Lee Hornback, reported the early returns on November 1, 1960. With only 100 of 1,301 precincts reporting, Vice Pres. Richard Nixon had a slight lead over Sen. John F. Kennedy in Hamilton County, but it was still too close to call. (Photograph by Bill Myers.)

In 1958, WCPO-TV created an afternoon program in another attempt to draw news viewers from WLW-T and WKRC-TV. The *2:30 News*, starring Paula Jane, Henry O'Neil, and Ed Chapin, was cancelled after just a few months, convincing general manager Mortimer C. Watters that he needed to get serious about finding a news personality to compete with Peter Grant and George Palmer.

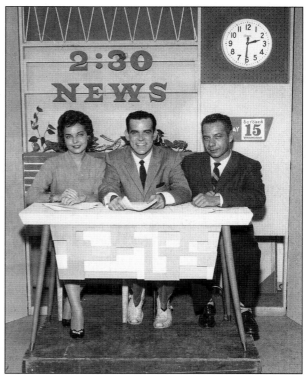

By June 1959, WCPO-TV had been on the air for 10 years without a news presence. Al Schottelkotte, a columnist for the *Cincinnati Enquirer* and nightly news anchor on WSAI radio, was hired to head up a three-man news department. They launched a 15-minute 11:00 p.m. newscast six nights a week. Soon Schottelkotte expanded it to 30 minutes and added news at noon and 6:00 p.m., all of which he personally anchored. (Courtesy WCPO.)

WCPO-TV televised its first live news remote on May 15, 1961, from the Campbell County Courthouse in Newport, Kentucky. The sensational trial involved "clean-up crime" sheriff candidate George Ratterman and a botched attempt by organized crime to drug him, place and photograph him with a stripper, and discredit his campaign. WCPO engineers reassembled station cameras in the courthouse where Allan White (pictured) interviewed Ratterman and others live from the trial. (Courtesy WCPO.)

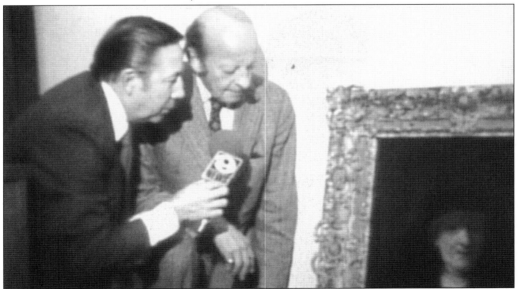

For 22 consecutive years, Al Schottelkotte anchored Cincinnati's top-rated newscast. When Cincinnatians became aware of something newsworthy, they told Channel 9 first. In 1973, when Rembrandt's *Portrait of a Woman* was stolen from the Taft Museum, the recovered masterpiece was turned over to Schottelkotte, who is shown here at left with Taft Museum president John Warrington. They examined the rare artwork live on the air for WCPO-TV viewers before allowing the police to claim it. (Courtesy WCPO.)

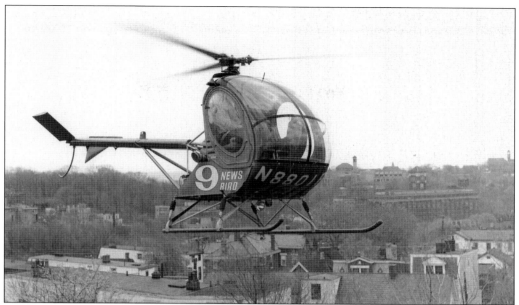

In 1967, WCPO-TV was the first Cincinnati news department to use a helicopter. Al Schottelkotte hired Larry Mason as a news photographer. Mason was also a pilot and owned a two-seater chopper. "The News Bird" made an immediate impact on spot news coverage and remained an effective part of the *Al Schottelkotte News* until Mason and his helicopter left Channel 9 in 1972. (Courtesy WCPO.)

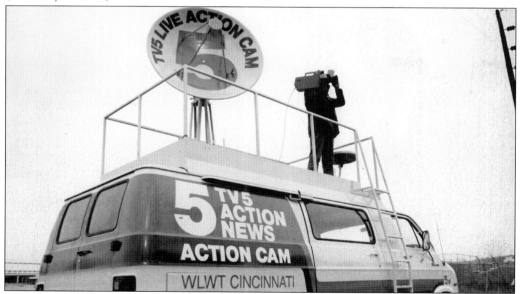

Originally television news was collected on film, requiring at least 30 minutes to process before sharing with viewers. In October 1974, WCPO was first to use portable videotape. One year later it was again first, connecting its Instacam with microwave technology to provide instant live news coverage. Soon after Channel 9's introduction, WKRC-TV and WLW-T added EDGE (Electronic Data Gathering Equipment) and Action Cam portable cameras, respectively, and WKRC-TV added live capabilities on Friday, May 27, 1977.

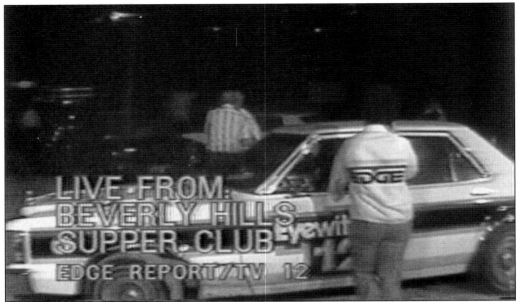

All three news departments discovered the importance of new technology on May 28, 1977. At 8:15 p.m., stations received reports of a fire at the Beverly Hills Supper Club in Southgate, Kentucky. WKRC-TV was first on the scene with EDGE, followed closely by Channel 9's Instacam. Without microwave equipment, WLW-T was forced to rely on delayed images. (Courtesy WKRC-TV.)

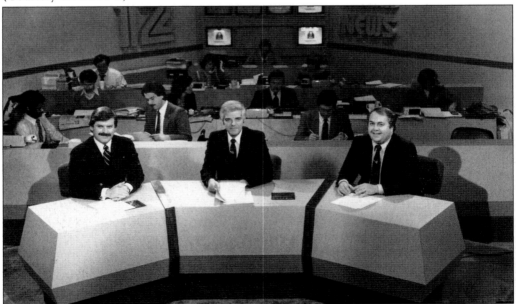

When WKRC-TV's Dennis Janson (left), Nick Clooney (center), and Ira Joe Fisher became Cincinnati's top news team in 1982, it was front-page news. They were the team that dethroned the *Al Schottelkotte News* after 22 years at the top. Clooney, with his signature "news with a heart" approach, was the only main anchor to report from the Beverly Hills Supper Club fire. (Courtesy Nick Clooney.)

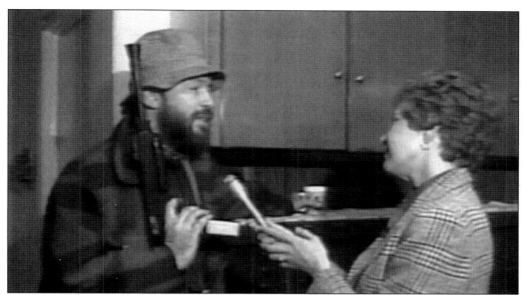

At 2:05 a.m. on October 15, 1980, WCPO-TV reporter Elaine Green and her crew were returning from a story when murderer James Hoskins, armed with a machine gun, took Green and eight others hostage. Remaining calm, Green suggested Hoskins share his story on videotape and interviewed him while at gunpoint. When finished, Hoskins released the hostages and then killed himself. Green received the Peabody Award, television's highest honor, for her report on the incident. (Courtesy WCPO.)

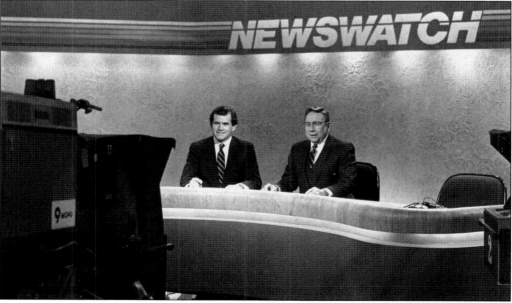

By the early 1980s, Cincinnati was being wired for cable. Viewers' tastes were changing. News was more instant. Al Schottelkotte, pictured at right with Jon Esther, was losing his two-decade dominance on news. In 1982, Schottelkotte left the 11:00 p.m. news, and on August 29, 1986, he left the 6:00 p.m. news with his trademark—"May it all be good news to you." Schottelkotte died on Christmas Day 1996. (Courtesy WCPO.)

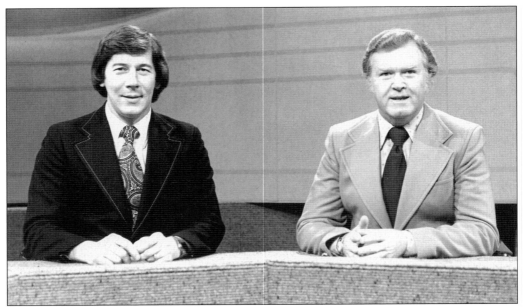

WLW-T's Peter Grant and WKRC's George Palmer left their anchor positions in the late 1960s. Both had become synonymous with their stations' news image. Tom Atkins (right), from 1966 to 1977, and Steve Douglas, from 1970 until 1976, were Channel 5's first attempt to find a news team to replace the popular Peter Grant and his longtime former coanchor, Glenn Wilson. (Courtesy WLWT.)

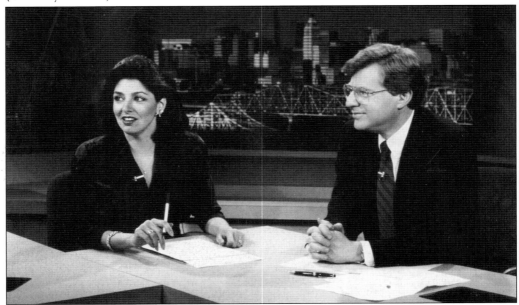

Jerry Springer was Cincinnati's popular city councilman in 1971, "Boy Mayor" in 1977, and WEBN radio commentator from 1976 to 1982 before joining WLWT as commentator and news anchor from 1982 to 1993. Springer and coanchor Norma Rashid became Cincinnati's number one news team in 1988 and remained on top for five years until Springer left Cincinnati to host his own talk show in 1993. (Courtesy WLWT.)

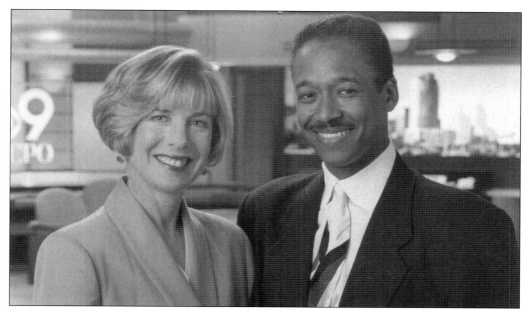

In 1986, after six years at WGAL-TV in Lancaster, Pennsylvania, Carol Williams replaced Al Schottelkotte as coanchor of the Channel 9 news with Pat Minarcin. Clyde Gray came to Cincinnati to anchor the news at WLWT from anchor positions in North Carolina and Maryland. In 1991, Gray joined WCPO-TV and she and Williams became Channel 9's main anchor team. (Courtesy WCPO.)

Kit Andrews joined WKRC-TV in April 1981 as a general assignment reporter from Spokane, Washington. Rob Braun, son of longtime WLW-T talk show host Bob Braun, began his news career in Knoxville, Tennessee, before coming to Cincinnati as a reporter in 1984. Rob and Andrews became Channel 12's main anchor team in 1991. (Courtesy WKRC-TV.)

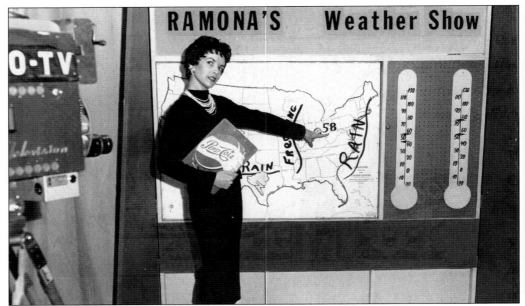

Ramona Burnett was a secretary in Nashville, Tennessee, before joining WCPO-TV as Cincinnati's first weather girl. The weather girl phenomenon was common on local stations in early television. The five-minute weather show aired weeknights at 7:25 p.m. on Channel 9 and was sponsored by Pepsi-Cola and written and directed by Paula Jane Schultz. (Courtesy Cincinnati Post.)

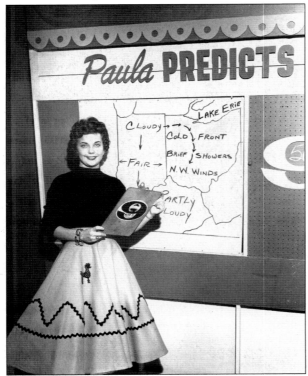

Before the creation of the news department in 1959, Paula Jane Schultz, who viewers knew as Paula Jane, presented the weather three times daily on WCPO-TV. The noon edition of *Paula Predicts* was delivered in casual clothing while the 7:00 p.m. and 11:15 p.m. reports were more formal. She appeared on many other Channel 9 shows, including *Romper Room*, *This is Music*, *Record Hop*, and *Front and Center*. In 1958, she married WCPO-TV general manager Mortimer C. Watters.

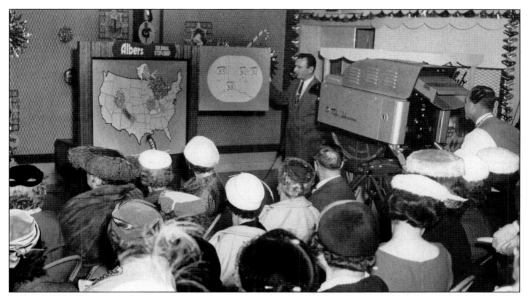

When WLW-T created a weather station for its newscast in 1954, weather forecaster Jim Fidler hired Tony Sands as the first meteorologist. Sands, born Anthony Sadouskas, was Cincinnati's best-known meteorologist for 33 years, broadcasting on Channel 5 news and Ruth Lyons's *50-50 Club* (pictured). In addition to introducing color maps to local weather, Sands became the first to use radar even before the Cincinnati weather bureau had radar equipment. (Courtesy WLWT.)

Shell Oil sponsored the WKRC-TV weather report, presented by Daryl Parks. Many parts of the Shell Weather Tower were manually operated. Turning the knobs and spinning the oil cans to reveal high and low temperatures was the responsibility of interns and the props crew, who would crawl behind the set and wait for Parks's cues. (Courtesy Cincinnati Museum Center.)

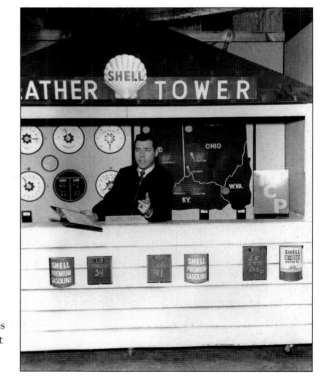

Among his many announcing duties between 1958 and 1982 at WLWT, Bill Myers reported the weather weekdays on the *Bob Braun Show* from atop the Comex building at Ninth and Elm Streets. During his January 7, 1975, report, a gorilla climbed the roof and began chasing him. Everyone, except Myers, thought it was hilarious. After a few frightening moments, he realized it was an agile circus performer in an extremely convincing costume. (Courtesy Bill Myers.)

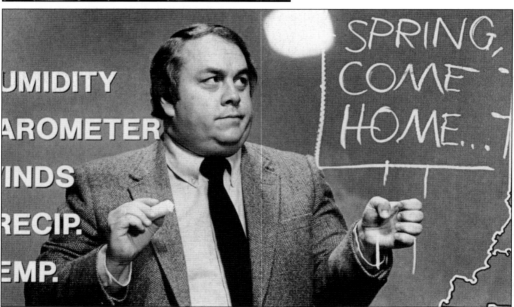

Ira Joe Fisher arrived in Cincinnati from Spokane, Washington, in 1980. His quick wit and ability to draw backward on Plexiglas while delivering his weather forecast made him an immediate viewer favorite on Channel 12. Since he was only seen on air sitting behind the desk or above the waist at his weatherboard, Fisher often delivered his forecast wearing a suit coat and tie with shorts and sandals.

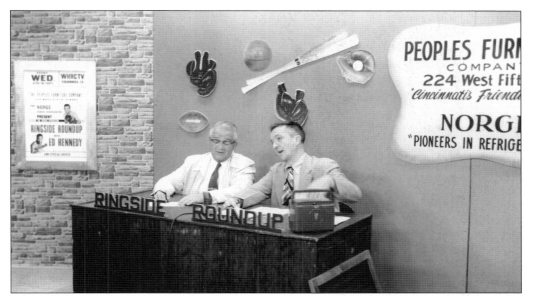

Sports programs have long been a television favorite for fans. Ed Kennedy was one of the earliest hosts with his *Ringside Roundup* show on WKRC-TV, presenting last week's results and previewing upcoming sports every Wednesday night after boxing. Kennedy (right) welcomed weekly guests like Ohio State football coach Woody Hayes. Kennedy was also the play-by-play Cincinnati Reds baseball announcer on WLW-T from 1961 to 1970. (Courtesy Cincinnati Museum Center.)

New York Yankees hall of fame pitcher Waite Hoyt (left) was the radio voice of the Cincinnati Reds from 1942 to 1965. He was WCPO-TV's first sports anchor, signing on during its first year of news in 1959 and leaving at the beginning of the 1961 baseball season. In 1962, Hoyt's Cincinnati Reds broadcast partner, Jack Moran (right), joined Channel 9 as sports anchor, where he remained for 20 years.

Phil Samp was the sports voice of Peter Grant's WLW-T news team for more than a decade, beginning in 1964. In 1968, Samp became the first play-by-play broadcaster for the American Football League expansion franchise Cincinnati Bengals in addition to his sports anchor duties. He left Channel 5 news in 1977 and remained the voice of the Bengals until the end of the 1990 season. (Courtesy Cincinnati Post.)

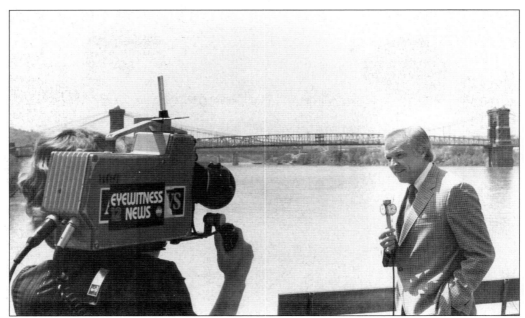

Walt Maher may best be remembered for his years as sports anchor on Channel 12 news, but he began his Cincinnati on-air career with 17 years on Channel 9, where he started in 1961 as reporter and weekend anchor. Maher moved to WKRC-TV in 1978, where he was a sports reporter and anchor and the sports director until 1997.

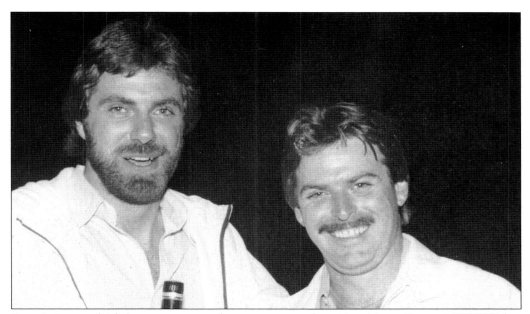

Dennis Janson (right) was a news anchor, reporter, and movie critic at Dayton's WLW-D but left the business in 1974. While working as a bartender in Mount Adams in 1977, he accepted a job from WKRC-TV sports anchor Fred Wymore (left) editing Beverly Hills Supper Club fire footage. Janson became the Channel 12 sports anchor in 1978 and helped the team become the top-rated Cincinnati newscast. Janson moved to Channel 9 in 1984.

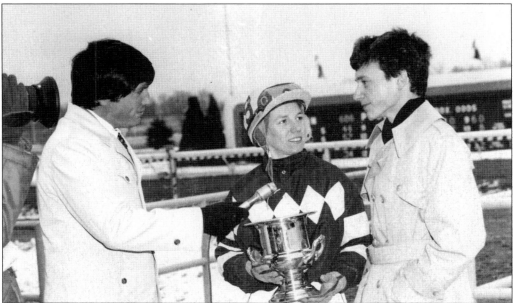

John "Popo" Popovich (left), pictured interviewing jockeys P. J. Cooksey and Steve Cauthen, is an outstanding storyteller and skilled writer, making him one of the most respected sports journalists in Cincinnati television history. Since joining WCPO in 1979, he has been a sports reporter, sports anchor, and sports director. He also hosted *Sports of All Sorts*, the Sunday night sports show he created in 1980 and produced for decades.

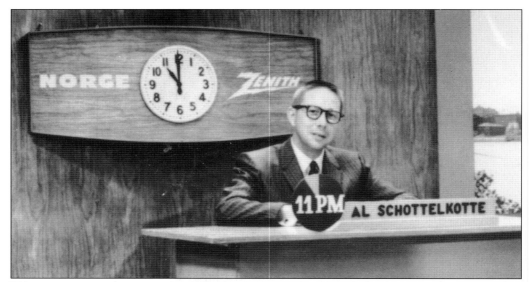

Television news today is very careful to separate news content from commercial content. That was not the case in the early days, when the sponsoring companies' names and logos, such as Zenith televisions and Norge appliances, were always visible on the WCPO-TV news set behind Al Schottelkotte. (Courtesy WCPO.)

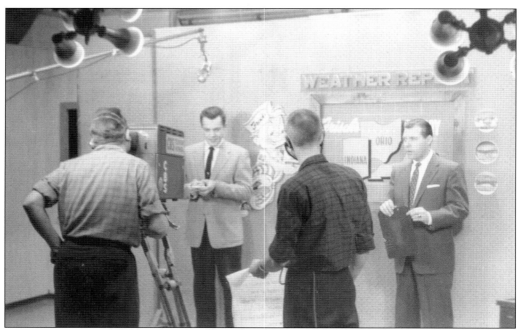

Weather reporter Daryl Parks and station announcer George Bryant stood side-by-side when delivering the Frisch's sponsored WKRC-TV forecast. Bryant delivered the commercial ending with "Try a fresh, juicy Frisch's Big Boy." Bryant would take a bite and smile before the camera returned to Parks. Frisch's delivered the hamburgers hours before broadcast and, being cold, they usually were spit out immediately after Bryant was off camera. (Courtesy George Bryant.)

Satisfaction Guaranteed

Try our friendly 12 O'Clock Noon Report news team to get fast, fast action to the "what's-going-on-in-the-world" blahs. We even have free gifts for you!

☐ Free! A daily tour of Cincinnati with guide Jack Fogarty featuring such outstanding places as the City Dump, dried out goldfish ponds, inside the jail and an indepth look at the sewer system.

☐ Free! A chance to win a portable television from Walt Maher.

☐ Free! Free tips from that "little-room-in-the-back . . ." Rainy Day in the Third . . . Rainy Day on Tuesday . . . Rainy Day on Wall Street . . . in addition, sports, weather and stocks.

If you don't see what you want . . . ask for it.

Name _____

Address _____

City _____ Zip _____

Comments _____

noon REPORT
WALT MAHER/JACK FOGARTY/JON BRICSTON
WEEKDAYS WCPO/TV 9

Al Schottelkotte created the *Noon Report* in 1960 to compete with Ruth Lyons's popular talk show. Schottelkotte turned over the noon anchor chair to Walt Maher in 1965. Over the next few years, the *Noon Report* became the top-rated noon show in Cincinnati. In 1971, WCPO-TV took a unique approach to promoting its noon news with Maher and reporters Jack Fogarty and Jon Bricston. (Courtesy Suzie Maher Haas.)

Most people remember Dick Von Hoene as the Cool Ghoul on Channel 19's *Scream-In*, but few remember that he was Channel 19's first news anchor. WXIX launched its 10:00 p.m. newscast in 1996, but in the 1970s, Von Hoene presented five-minute news capsules several times each day. Von Hoene was a reporter and news anchor for many of his 40 years on radio, television, and Northern Kentucky cable.

In April 1987, Channel 9 news anchor Pat Minarcin received an anonymous tip from a nurse at Drake Memorial Hospital suggesting someone check into a series of mysterious deaths. Minarcin's research led to the discovery that Drake orderly Donald Harvey, nicknamed "Angel of Death," had poisoned 37 people. Two days after Minarcin's half-hour commercial-free broadcast, a grand jury convened to investigate, and within two months Harvey confessed. (Courtesy Cincinnati Post.)

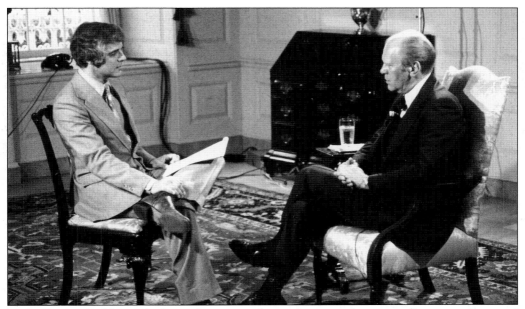

Nick Clooney had been the host of a teenage dance show, an afternoon talk-variety show, and national game show, *The Money Maze*. On Monday, May 24, 1976, Clooney resigned as WCKY radio's early morning drive-time disc jockey. On June 2, he replaced Mark Edwards as Channel 12 reporter-anchor and scooped even the Washington press corps in a White House interview with Pres. Gerald Ford. (Courtesy Bill Renken.)

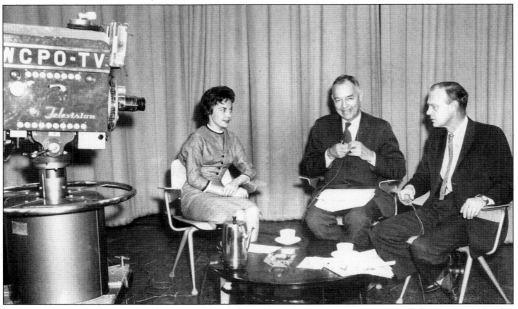

On May 6, 1960, George Palmer was fired from his anchor position at WKRC-TV. In 1961, he joined Channel 9 to host the *George Palmer Show* weekday mornings from 7:30 to 8:30 and *Front and Center* from 10:15 a.m. to 10:30 a.m. Palmer (right), with weather girl Paula Jane and Cincinnati councilman and former mayor Charles P. Taft, returned to Channel 12 and resumed his role as the main anchor in May 1962.

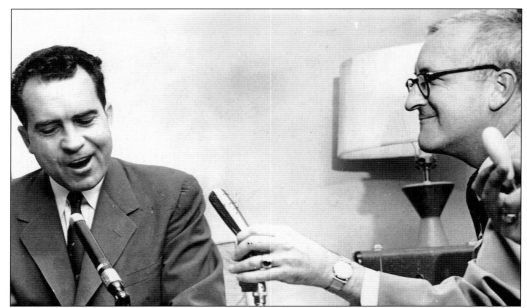

In addition to news, weather, and sports anchors, viewers tuned in to see their favorite reporters. On Channel 9, the *Jack Fogarty at Large* reports began with his trademark "I may be wrong but…" and highlighted community places and people. For more than 40 years, Fogarty (right), interviewing Pres. Richard M. Nixon, covered the biggest stories in Cincinnati, including his eyewitness broadcast from the window ledge of the Carew Tower as he talked a man out of jumping. (Courtesy WCPO.)

In 1959, Allan White, pictured with a microphone interviewing former president Harry Truman, was a reporter for the *Cincinnati Post* and read radio news on weekends for WCPO-AM. Al Schottelkotte asked White to join him as news editor. Over the next 30 years, White became one of the most respected newsmen in Cincinnati and moderator of the Sunday evening discussion show *Impact*. (Courtesy WCPO and Allen White.)

Four

GROWING UP ON TELEVISION

World War II ended in 1945, opening the door for two world-changing births, baby boomers and television. Early television programmers pigeonholed viewers. Daytime talk shows and soap operas were for housewives. News and sports were directed to men. Programmers needed to find ways to attract the boomers while they were babies, then inform and entertain them as they grew.

Cincinnati's most popular children's program began by accident. WCPO-TV general manager Mortimer C. Watters suggested that station art director, Al Lewis, create a show to fill some time. Lewis drew a set and called the show *Al's Corner Drugstore*. Viewers called the station requesting songs for Lewis to play on his accordion. Children from the Walnut Hills neighborhood wandered into the studio, so Lewis invited them onto the set. They requested songs, Lewis played them, and the children danced. Parents called the station asking how to get their children on the show. On June 12, 1950, *Al's Corner Drugstore* closed and *The Uncle Al Show* began.

At WKRC-TV, Glenn Ryle was a newscaster and late-night movie host in 1955 when station general manager, David Taft, suggested a children's show as a summer replacement. The idea was to have a river-type show since Cincinnati was a river town. That was the beginning of Skipper Ryle's 17 years of playing games, watching cartoons, and teaching baby boomers in the studio and on television.

As Cincinnati boomers became teenagers, *Bandstand, Teen Canteen, Juvenile Court, Soupy's Soda Shop, The Bud Chase Show*, and others worked to attract them. One of the most successful was WCPO-TV's weekly four-hour *TV Dance Party*. Each Saturday Channel 9 hosted 350 high school students who danced in the Coca-Cola Bottling Works auditorium in Evanston and competed for prizes.

By 1985, the children of the baby boomers were watching *Sesame Street* and children-focused cable networks. So on May 29, 1985, Uncle Al taped his final episode. In 35 years, an estimated 439,000 Cincinnati children had appeared on his show.

Here is a look at the shows aimed at those growing up in Cincinnati with the following words of Uncle Al: "Alakazam one, Alakazam two, Alakazam three and poof."

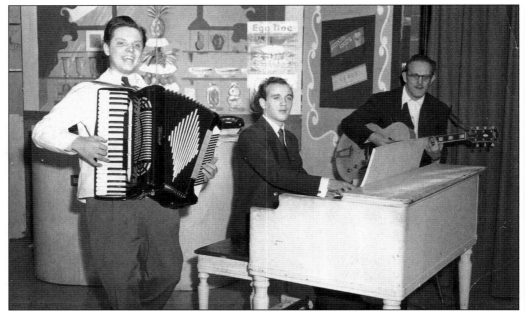

This is where it all began. It was called *Al's Corner Drugstore*, a daily show with Al Lewis on accordion, Jimmy Cain on piano, and an unidentified person on guitar. The trio would play requests from viewers who called the station. When Lewis invited a few visiting kids into the studio, the foundation for the longest-running children's show in history was born. (Courtesy WCPO.)

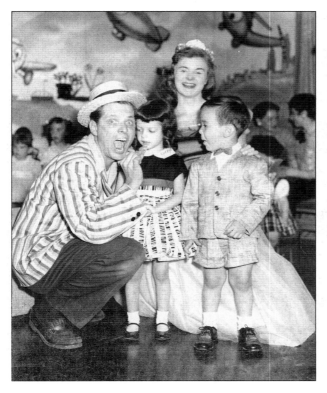

Although he was born Albert Lewis Slowik in Cleveland, using the name "Uncle Slowik" was never considered. He changed his name while working as a disc jockey and radio announcer in northern Ohio before joining WCPO-TV in 1949. Lewis invented his show as he went along, moving quickly from songs to games to dances to puppets, to keep young attention spans from wandering. One of his earliest sidekicks was Princess Ann. (Courtesy WCPO.)

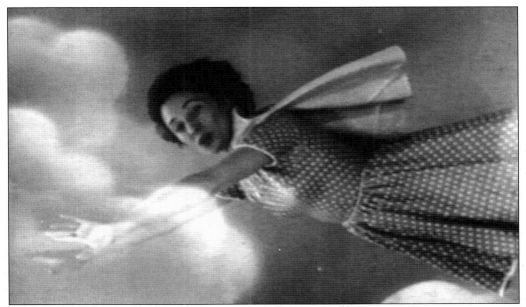

Paul Dixon nicknamed Wanda Lewis "the Windy One" because of her shy, quiet manner. After Dixon moved to WLW-T, Lewis created the character "Captain Windy," who remained with *The Uncle Al Show* until the final episode. Early in each show, Uncle Al would have the kids "look up into the sky to see Captain Windy flying so very high." Then through the magic of television special effects, Captain Windy flew into the studio. (Courtesy WCPO.)

In 1953, Mike Tangi joined *The Uncle Al Show* as a producer, director, scriptwriter, songwriter, and voice of 33 animals and puppets. Tangi sat in the control room switching between moving crews, changing cameras, and talking to Uncle Al in character voice. Tangi's most famous Uncle Al song was "Put Your Toys Away," which began his career writing advertisements and jingles. (Courtesy Mary Lynn Tangi.)

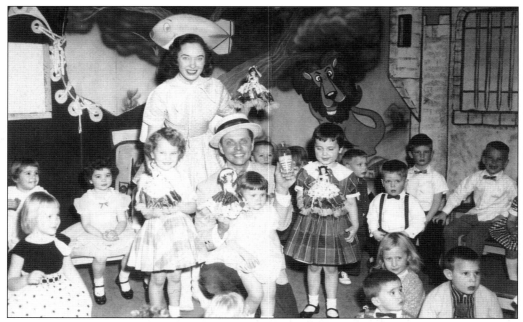

In the early days, WCPO aired three one-hour Uncle Al shows each day. It was so popular that in 1955, CBS asked Uncle Al to host a similar show on its network. Since WCPO was affiliated with ABC, Lewis declined, so CBS settled on Bob Keeshan to host its new show *Captain Kangaroo*. (Courtesy WCPO.)

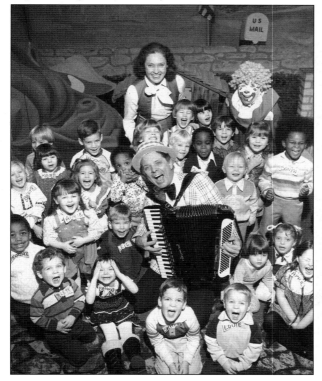

Beginning in the 1960s, every child who appeared on *The Uncle Al Show* was given a personalized bow tie sticker. Children were told that they were tickets to get in and souvenirs to take home. In truth, they were so that Uncle Al could call each child by name. (Courtesy WCPO.)

Many Cincinnati broadcast personalities appeared on *The Uncle Al Show*. Bob Shreve was Bozo the Clown and Roger the Robot. In 1957, 18-year-old Larry Smith joined Uncle Al, beginning a puppeteering career that spanned more than four decades. In 1970, eight-year-old George Clooney (above left with his Uncle Al tie) made his first television appearance on *The Uncle Al Show* as a ship's captain in a skit.

On May 29, 1985, Uncle Al taped his final show. There was one final "Hokey Pokey," one final "Put Your Toys Away," and, as always, the show ended with a prayer, "Thank you for the songs so sweet, thank you for the food we eat, thank you for the birds that sing, Thank you, God, for everything!" Then the children marched to one final verse of "It's a Small World." (Courtesy WCPO.)

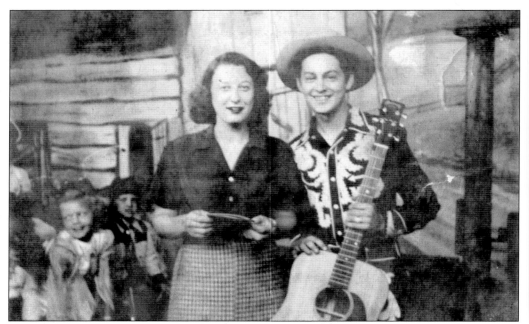

Judy Perkins and Neal Burris hosted one of the earliest children's shows on television, WLW-T's *TV Rangers*. Children visited the Mount Olympus studio to sing, talk, and meet visiting television and movie stars. The show ran from late 1949 to 1951, and lucky kids received *TV Rangers* membership cards. (Courtesy Judy Perkins Sinclair.)

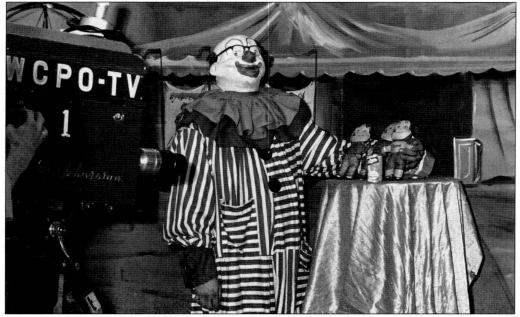

It was not unusual for station personnel to have multiple responsibilities in the early days of television. Channel 7's program director Ed Weston also played "Coco the Clown." Often the audience would see Weston in the back of the studio making telephone calls and dictating business letters while still in his Coco costume and makeup. (Courtesy WCPO.)

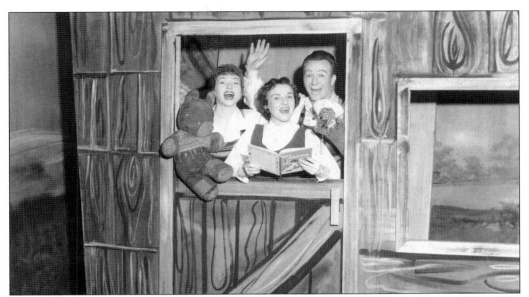

Jelly Bean Acres was one of WKRC-TV's early-morning shows for young viewers. Marti Kay (left), Shirley Jester, and Roy Starkey read stories, sang, and talked with puppets. Dudley Taft, future head of WKRC-TV owner Taft Broadcasting, spent his summer internship on the eighth floor of the Cincinnati Times-Star building operating puppets in the window to the right. *Jelly Bean Acres* ran for several years in competition with *The Uncle Al Show*. (Courtesy Cincinnati Museum Center.)

Captain Glenn's Play Club, later called *Captain Glenn's Bandwagon*, rolled into Cincinnati homes weekday mornings on WLW-T in 1952. The show starred Rosemary Olberding and "Captain Glenn" Rowell (right) with his ever-present stovepipe hat, singing, playing the piano, and talking with a gang of puppets, including Yougo, a brash British dog who is peeking over the horse's mane on the hand of the "man of many voices," Cy Kelly. (Courtesy Rosemary Kelly Conrad.)

Before he was Cincinnati's favorite skipper, Glenn Ryle Schnitker was Captain Midnight on his short-lived children's show on WCPO-TV. Ryle began his television career in 1951 at WCPO working on *The Dotty Mack Show*, Paul Dixon's show, and *The Uncle Al Show*. In October 1954, Ryle moved to WKRC-TV as a newscaster and host of the late-night movie.

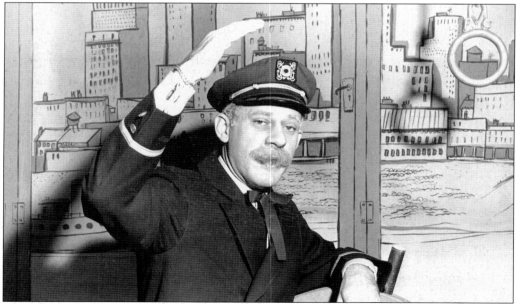

After 10 years as a marine with four purple hearts for his service in World War II and the Korean War, Glenn Ryle reported for active duty as Cincinnati's riverboat "Skipper" Ryle. Originally a summer replacement show, it was called *Hi, Kids* but quickly became the *Skipper Ryle Show* aboard the mythical *River Queen*. The early bushy grey hair and mustache were replaced by the younger Skipper Ryle most Cincinnatians remember.

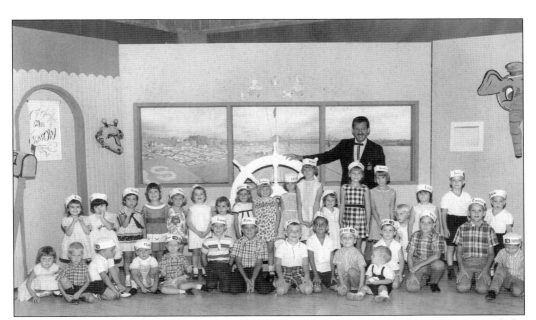

Skipper Ryle spent 17 years playing games, watching cartoons, and teaching Cincinnati baby boomers in the studio and on television. The Sunday *Skipper Ryle Show* included a live studio audience of 150 children. He was different from the other Cincinnati children's show hosts. He never got down on the floor and played and never talked down to the children. He chose activities that were more grown-up.

For many years, Skipper Ryle spent part of each show on the Mother Goose set, which was designed with everything half size to make Skipper look big. After knocking on the door and crawling to his chair, Skipper talked to Mother Goose (center) who was voiced by Mike Tangi and operated with wires by production assistant Tom McCarthy (left). Skipper then read a story with an important moral or lesson.

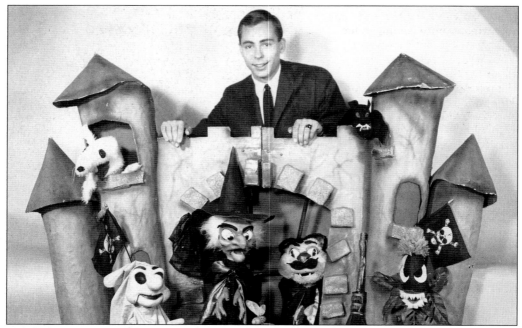

Larry Smith made his television debut at age 14 on Dayton WHIO-TV's *The Tic Toc Toy Shop* earning $3 per show for his two-year run. In 1957, Smith joined WCPO-TV to perform on *The Uncle Al Show* and his own show, *Puppet Time*, that aired weekdays from 8:00 to 9:00 a.m. Three of his most popular characters in this 1963 promotional photograph are Snarfy R. Dog (in the tower), Spooky the Ghost, and Hattie the Witch.

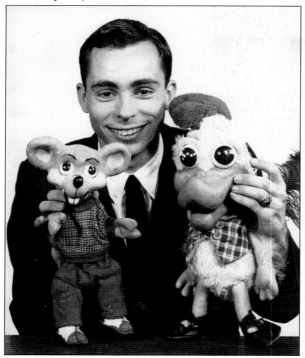

In 1961, Smith took his cast of characters to WKRC-TV to star in *The Rudy and Teaser Show* with Rudy the Rooster and Teaser the Mouse. The show lasted one year before Smith, Rudy, Teaser, Hattie, and the others returned for a second three-year run on WCPO-TV. In between stints on Cincinnati television stations, Smith worked on Broadway with *Kukla, Fran, and Ollie* star Burr Tillstrom and Muppets creator Jim Henson.

The rabbit sat motionless in the toy store window until coming to life as the "ten-foot-tall bunny-host" of WLW-T's *Mr. Hop. Mr. Hop* was created and played by Dave Manning, sharing stories, performing skits, and introducing cartoons with his sidekick, Artie Mouse, played by Jack Louiso. All the shows were scripted and prerecorded, with the speed of the tape recorder increased to give Mr. Hop his cartoonish voice. (Courtesy WLWT.)

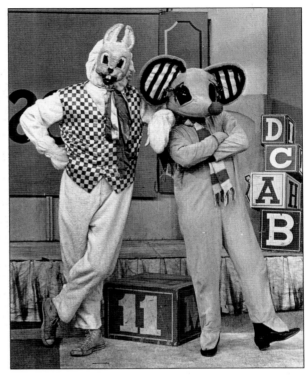

Arthur Erwin Churvis was better known as "Stringbean" Bud Chase (right) on WCPO-TV's *Bean's Club House*. The show began in 1955 as a wraparound for *Our Gang, Laurel and Hardy*, and cartoons. His partner was the "Mean Widdle Kid" Louie Spoboda, played by Lee Fogel. In 1957, Bean moved into an "underground clubhouse" that was entered via a basement window. Chase hosted the show weekday afternoons until moving to Chicago in 1959. (Courtesy WCPO.)

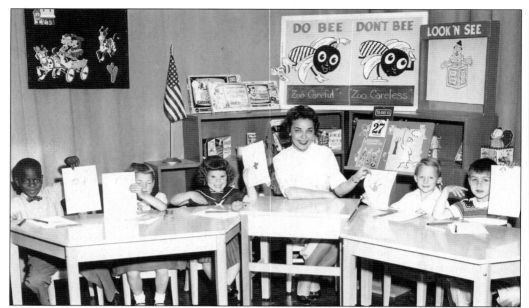

"Romper, bomper, stomper boo. Tell me, tell me, tell me, do. Magic mirror, tell me today. Have all my friends had fun at play?" Paula Jane "Miss Paula" hosted *Romper Room* on WCPO-TV with one hour of games, songs, and moral lessons. Cincinnati children were encouraged to appear on the show or write letters to the station so Miss Paula could "see Zachie and Tyler and all of you good boys and girls out there." (Courtesy WCPO.)

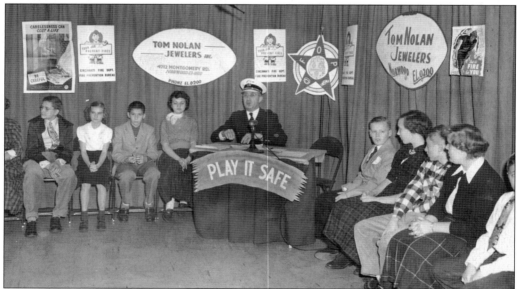

Every Saturday at 7:30 in the morning on WCPO-TV, Capt. John Turigliatto blew his whistle and shouted, "Stop what you're doing! It's time to . . . Play It Safe!" Students from Cincinnati area schools talked with the police officer and answered questions about safety. *Play it Safe* was one of many police programs on Channel 9 throughout the years, including *F.O.P. Quiz* and Lt. Arthur Mehring's 1951 five-minute evening broadcast, *Police Blotter.* (Courtesy Cincinnati Police Museum.)

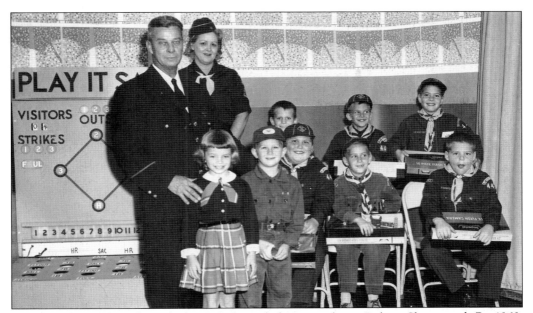

Several police officers hosted *Play It Safe,* including patrolman Robert Shearwood. By 1963, teams answered questions about safety while moving along the game board. The team to finish first received prizes, such as the camera set won by these Mount Washington cub scouts. Others would grab as many pennies as they could from a jar, courtesy of Provident Bank. Rosemary Holland (above), with Shearwood, was nine years old when she appeared on the show.

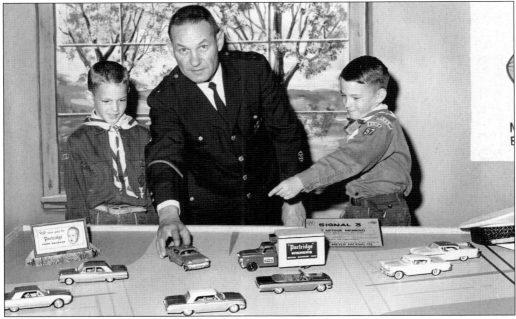

WLW-T's *Signal 3* with Lt. Arthur Mehring aired Saturday at 9:30 a.m. The show, sponsored by Partridge Meats, taught young viewers about safety. Visitors from schools, scout troops, churches, and clubs made up the studio audience from which contestants were selected. Mehring is the officer for whom Cincinnati's downtown street Mehring Way is named. (Courtesy WLWT.)

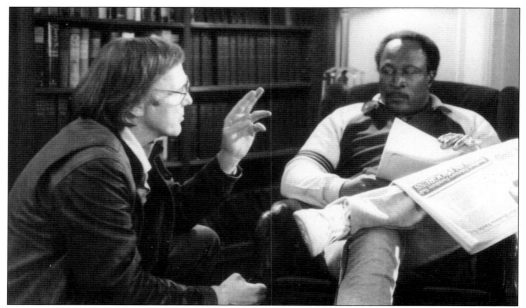

In 1976, Tom Robertson (left) created *Young People's Specials*. In 15 years, Robertson and his crew produced more than 70 original half-hour dramas touching on controversial subjects, including alcohol, drugs, and sex. The series aired on WLWT and nationally on NBC stations and was used as a teaching aid in schools. Robertson, here directing John Amos in "Brother Tough," headquartered *Young People's Specials* on Mount Olympus. (Courtesy Bernie Dwertman.)

John Carradine (left) won an Emmy for his performance in the 1984 "Umbrella Jack" episode of *Young People's Specials*. It was also one of the earliest television roles for Joey Lawrence. The series gave many Cincinnatians a chance to work in front of the cameras and behind the scenes. Among them was Sara Jessica Parker, who got her acting break at eight years old in "The Little Match Girl." (Courtesy Bernie Dwertman.)

Dick Von Hoene created the Cool Ghoul at WCPO-TV in the early 1960s and auditioned him for *Shock Theater* host Bob Smith. Although he did not get the job, the Cool Ghoul made several appearances on radio before finding fame as the host of WXIX's Saturday night horror movie show *Scream-In*. Famous for his stringy orange hair and screeching his "Bluhhhh-bluhhhh" tagline, the Cool Ghoul ran weekly from 1969 to 1973. (Courtesy FOX19.)

As television grew up and cable television became more popular, there were fewer shows for young viewers on the local stations. Michael Flannery was one of the last local kids' show hosts from 1990 to 1995 on FOX19. He hosted, wrote, and produced two shows, including *Club Nineteen* and *Fridays Are Fun*. Flannery spent 13 years headlining at comedy clubs and was named Showtime's Funniest Person in Ohio. (Courtesy FOX19.)

Soupy Sales, born Milton Supman in North Carolina, grew up in West Virginia where he was the area's top disc jockey while moonlighting as a stand-up comic. In 1949, Sales moved to Cincinnati to host a morning radio show and perform in nightclubs. While in Cincinnati, he began his television career as Soupy Hines on WKRC-TV with *Soupy's Soda Shop*, believed to be television's first teen dance program. (Courtesy Cincinnati Museum Center.)

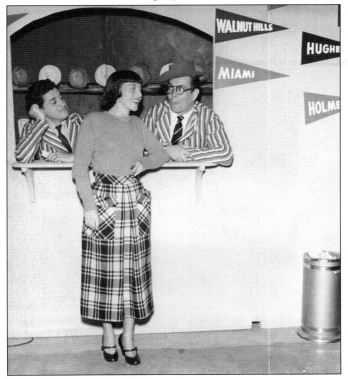

Betty Clooney was only 14 when she began her broadcast career on WLW radio's *Moon River* with her sister Rosemary. In 1949, Rosemary went solo and 18-year-old Betty (above) hosted her own show, *Teen Canteen*, with Len Goorian (left) and Bill Nimmo. On weekdays at 4:00 p.m., 40 high school students visited Mount Olympus to sing, dance, and often perform in talent shows. (Courtesy WLWT.)

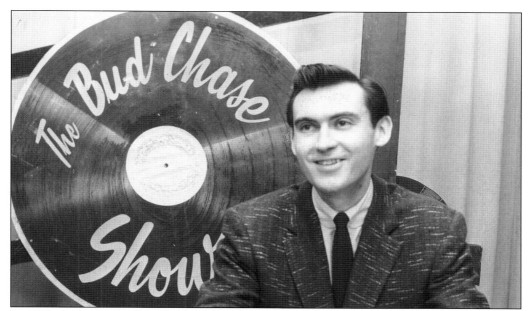

In 1952, *American Bandstand* debuted in Philadelphia the same year WKRC-TV launched *TV Dance Derby* with disc jockey/host Bud Chase. In 1954, Chase moved to WCPO-TV where the show was renamed *Bud Chase Dance Derby* and finally *The Bud Chase Show*. In addition to music and dancing, Chase arranged a night on the town for a high school guy and girl appearing on the blind date segment of his show. (Courtesy Cincinnati Post.)

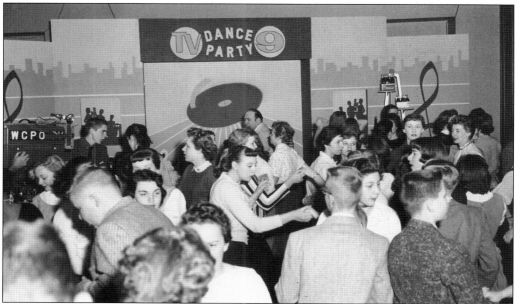

Every Saturday, 350 Cincinnati high school students attended the *TV Dance Party* broadcast live from Coney Island's Moonlite Gardens during the summer and from the Coca-Cola Bottling Company auditorium on Dana Avenue the rest of the year. In addition to dancing to recorded music, the students sang, pantomimed, twirled batons, and gave school cheers. National recording stars stopped by to talk with the students and judge dance contests. (Courtesy WCPO.)

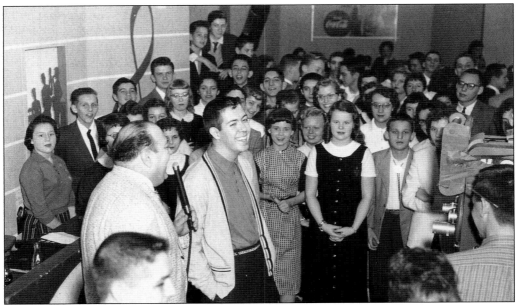

Teenage Dance Party replaced Bud Chase's *TV Dance Derby* in March 1956 with host Bob Braun. The three-hour Saturday afternoon show soon changed its name to *TV Dance Party*. When Braun left Channel 9 for Channel 5, Bob Smith, Myles Foland, and Dick Summer each spent time as host. Here Foland talks with Dale Wright of Dale Wright and the Wright Guys about his hit record *That's Show Biz*. (Courtesy WCPO.)

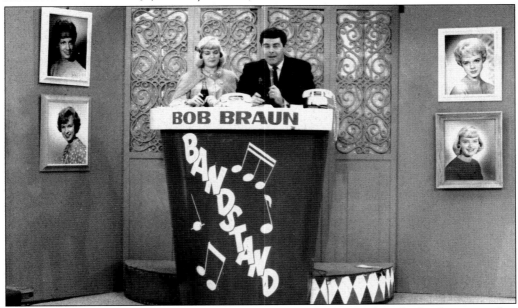

Bob Braun returned to the teen dance party scene in 1957 with *Bandstand*. The show started as a Saturday dance party at McAlpin's Tea Room, broadcast live on WLW radio. The television version ran on Sunday afternoons from the WLW-T studios. Braun, pictured here with one of his high school costars known as "gal Fridays," hosted the show until June 1966. (Courtesy the Braun collection.)

Nick Clooney, who once substituted for Dick Clark as host of *American Bandstand,* followed Braun as host of WLW-T's *Bandstand.* Clooney (left), cohost Johnny Walters, and gal Friday Jan Cleary played the latest records and talked with recording stars on what turned out to be the final Cincinnati television teen dance show. Cleary won the position in 1967, competing against thousands of local high school girls. (Courtesy WLWT.)

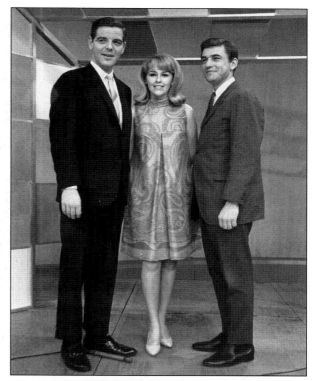

Cincinnati knew him as Judge Paul Trevor on WCPO-TV's weekly courtroom drama *Juvenile Court.* In real life, he was Sam Wilson, dean of the University of Cincinnati Law School. The judge was real, but the other participants were performers, often from the School for Creative and Performing Arts. Wilson was so strongly identified with his 1970s television persona that he was often asked to prove he was not a judge. (Courtesy Claire Richart.)

Cincinnati's *It's Academic* began in the 1960s on WLW-T and ran for 10 years before moving to WCET. The show had several hosts, including Dave Manning, Claire Slemmer, and Bill Myers. Every week, three local high school teams of three players answered questions and competed for scholarship money. The 1975 Wyoming *It's Academic* team of Matt Whitten, David Thompson, and Chris Rembold awaits a question from WLW-T host Steve Douglas. (Courtesy Wyoming Historical Society.)

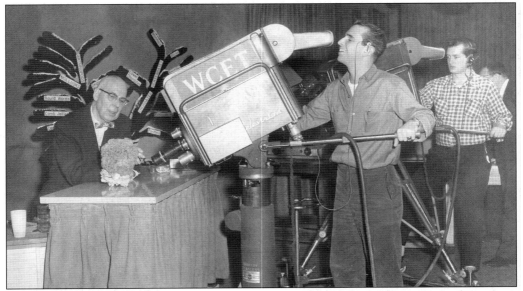

Stephen Smalley, a Withrow High School teacher with 20 years of experience, was Cincinnati television's science teacher of choice on WCET. He was excited about television's ability to share close-up visual aids. His only disappointment was missing students' reactions to his corny jokes and other banter during his 40-minute biology lecture, although cameramen Jim Kantrowe (left) and Frank Maus seem to enjoy his jokes during this 1959 presentation. (Courtesy Cincinnati Post.)

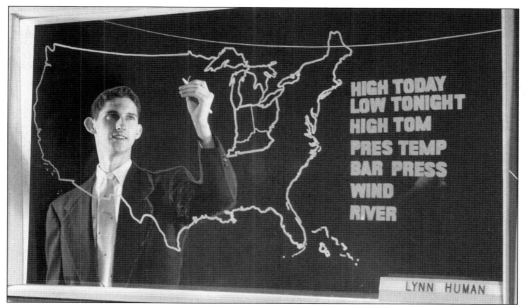

Lynn Human and seven other students from the College of Music of Cincinnati's Radio-Television Arts Department used WCET as their professional workshop, appearing regularly in 1954 as performers, announcers, and engineering staff. Human returned to Cincinnati after his tour of duty in Korea to finish his education in what appears to be an early salute to Ira Joe Fisher. (Courtesy Cincinnati Post.)

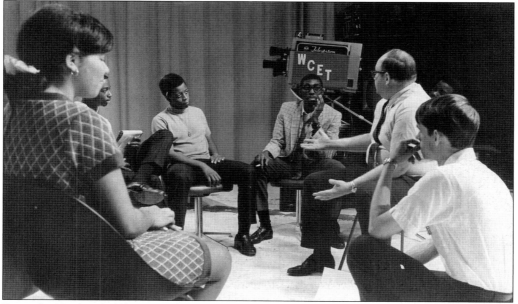

Focus On Youth, a half-hour weekly series, gave Cincinnati teenagers the opportunity to present their own television show. More than 100 teenagers wrote, produced, and directed the show, which ran on WCET at 7:00 p.m. during the summers of 1968 and 1969. From left to right are Valerie Walker, Edward P. Jones, Terry Thomas, Dwight Hill, Channel 48's Ron Wilson, and Fred Roth, working through story ideas in June 1968. (Courtesy Cincinnati Post.)

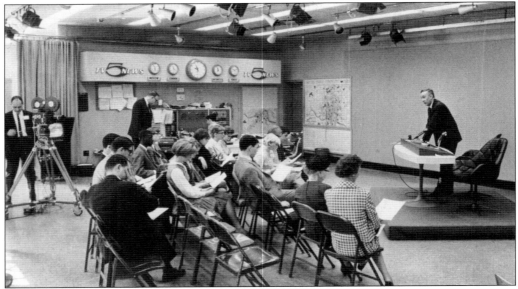

Cincinnati high school juniors interested in a television career were also given hands-on opportunities at WLW-T. Students spent a day each year behind the scenes working with and learning from Channel 5 news and documentary professionals. In the 1967 news seminar, students from Aiken, Western Hills, Courter Tech, Woodward, Walnut Hills, Withrow, Hughes, and Taft high schools listen to the comments of Avco Broadcasting news vice president Gene McPherson.

The Last Prom was one of the most memorable television specials for Cincinnati high school students. Most students remember the car crash, the bloodstained windshield, and the empty desks in the classroom. Gene McPherson produced The Last Prom for WLW-T in the 1960s and remade it in the 1970s and 1980s to update the clothing styles and automobiles. The program was also shown in driver's education classes to discourage drinking and driving. (Courtesy Gene McPherson.)

Five

AROUND TOWN

In a February 14, 1948, *Cincinnati Post* "T-Day" article, radio editor Mary Wood reported, "61 percent of the sets were in taverns but out of the last 100 sets sold here, 80 went into homes." By the middle of 1949, Cincinnati's three television stations were trying to attract home viewers, who had purchased more than 10,000 television sets during the past year.

So how did stations get viewers to watch their shows? Every way they could. The most important step was to connect the viewers with their favorite television personalities. Children who appeared on *The Uncle Al Show* continued to watch television. So at every possible opportunity, the stars performed, signed autographs, and became supporters of the community.

In the early days of television, Bob Braun and Paul Dixon made an annual pilgrimage to the Ohio State Fair to entertain and recruit viewers. Television personalities made numerous public appearances at Cincinnati's favorite summer spots, including Coney Island, LeSourdsville Lake, and the Cincinnati Zoo.

Television changed in many ways in its first 50 years. Gone are the talk shows that originated in Cincinnati. Those who learned from Ruth Lyons and Paul Dixon now broadcast from the coasts. Gone are the children's shows, and now a new generation no longer can jump and play and learn with a local television friend. Those who followed Uncle Al and Skipper Ryle are broadcasting new shows from far away places where a handful of children audition to join a national television friend. Gone are the game shows, how-to shows, dramas, and other programs that once were so specifically Cincinnati. Network, cable, and new financial models have made news the primary local television connection. That is not a bad thing, but it is a different thing. Television stations, reporters, and news anchors continue to turn their cameras on Greater Cincinnati. It is just that sometimes the city needs a Mayor of Kneesville, a late-night host with a rubber chicken, or an Uncle Al to remind us to "put your toys away." They were all a part of Cincinnati both on television and around town.

A 1939 visit to Cincinnati Children's Hospital left Ruth Lyons depressed with the thought of children hospitalized during Christmas. Sharing her concerns with her WKRC radio audience, she asked them to send change to help buy toys. Listeners sent $1,002. It was enough for a tree, decorations, and a gift for every child in the hospital. From that, the Ruth Lyons Children's Christmas Fund was born. Lyons (above) often visited the children, here with Frazier Thomas. (Courtesy WLWT.)

When Lyons retired in 1967, WLW-T pledged to continue her work for the Christmas fund. It begins annually on October 4, Lyons's birthday, and raised more than $19 million in its first six decades. Bob Braun (center), Rob Reider (left), Randy Weidner (top), and Dave MacCoy (bottom) took their music to Cincinnati Children's Hospital in 1971 to brighten the stay for many children. (Courtesy Dave MacCoy.)

Young Glenn Ryle, dressed as old Skipper Ryle, talked with young people on Fountain Square in 1957. Hundreds of Cincinnati families stopped at the square to drop off money and gifts for the Neediest Kids of All campaign while seeing the holiday trains at Cincinnati Gas and Electric and having their pictures taken with Santa at Shillito's. (Courtesy Cincinnati Museum Center.)

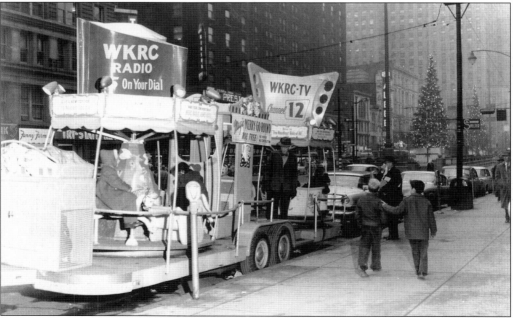

WKRC-TV and 55 WKRC Radio's Magic Merry-Go-Round, parked one block east of Fountain Square, was another way to alert Cincinnati holiday shoppers of the Neediest Kids of All toy drive. The Magic Merry-Go-Round stopped in shopping centers and holiday locations throughout the Greater Cincinnati area with WKRC-TV personalities. (Courtesy Cincinnati Museum Center.)

For many years, Cincinnati television stations supported the United Appeal, now United Way, by producing a television special highlighting the organization's good works. In 1953, WLW-T's Olympus Films' Jim Hill (crouching on curb) directs a scene in which his son Charlie plays a poor child hit by a car while playing in the street. The scene was shot on East Pearl Street, which is now Fort Washington Way. (Courtesy Dave Bartholomew.)

Television stations were expected to serve in the "interest, need and convenience" of their community in order to keep their broadcast licenses. This included creating and airing a number of public service announcements. Here WKRC-TV *Eyewitness News* cameras visit Spinney Field to capture Cincinnati Bengals' legendary coach Paul Brown in an early-1970s public service announcement for the Salvation Army. (Courtesy Visual History.)

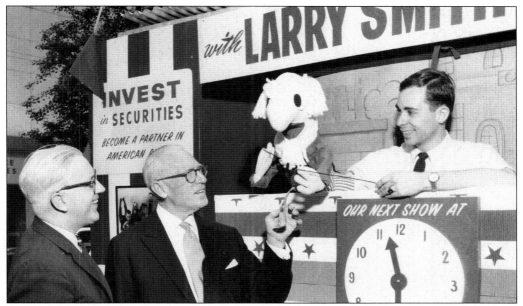

In May 1962, Larry Smith and his puppets explained the purpose of "Invest in America" week with four shows each day on Fountain Square. Smith (right) with one of the soft puppets from his WCPO-TV show, *The Contemporaries*, talks with Ed Hodgetts (left) of Cincinnati Gas and Electric and James Hutton Jr., who was general chairman for the event. (Courtesy Cincinnati Post.)

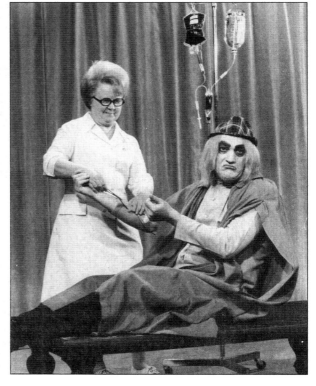

When the University of Cincinnati's general hospital needed donations, who better to alert the public? Beulah Wilson, R.N., (left) takes a sample from the Cool Ghoul to promote WXIX-TV's Second Annual Blood Bank television special to be aired on August 7, 1971, at 9:00 p.m. on Channel 19. Two years later, in 1973, the blood center was renamed for its founder, Dr. Paul I. Hoxworth.

Cincinnati television viewers loved seeing their favorite personalities around town. Baseball and television fans arrived early at Crosley Field to see the television stars play against the newspaper writers before the Cincinnati Reds' game. Pictured third from the right is Bob Shreve. Ruth Lyons stands in the center in white sunglasses with Bob Braun to her left. Paul Dixon is third from the left. Lyons coached the team to an 8-5 victory. (Courtesy Dennis Hasty.)

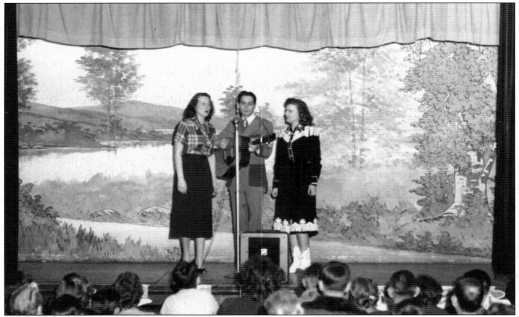

The stars of *Midwestern Hayride* take the stage in Brown County, entertaining fans in Mount Orab in 1950. Judy Perkins (left), Neal Burris, and Lee Jones played many live performances in the early days of broadcasting, encouraging fans to purchase television sets to watch their show. (Courtesy Judy Perkins Sinclair.)

More than 30,000 people, most of them excited children, visited Lunken Airport annually to see Santa arrive by airplane flown by his private pilot, Uncle Al. Uncle Al created this Cincinnati Christmas tradition to spend time with his young fans and raise money for the Mile of Dimes. Uncle Al and the characters from WCPO-TV's *The Uncle Al Show* performed an hour-long show for the children waiting to sit on Santa's lap.

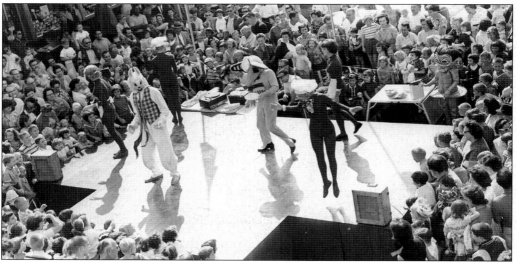

It was not the Easter Bunny who entertained children at Swifton Shopping Center in the 1960s. Mr. Hop, Artie Mouse, and friends danced to "The Teddy Bears' Picnic," performed skits, posed for pictures with fans, signed up youngsters for Mr. Hop's Minors' Club, and invited them to watch the *Mr. Hop* show on WLW-T. (Courtesy WLWT.)

One way television shows connected with the community was to produce episodes outside the studio. This was especially popular in the summer when Cincinnati's favorite shows visited one of the area's most popular summer locations. Always the entertainer, *The Paul Dixon Show* producer Len Goorian takes a break from rehearsal for the July 16, 1953, Dixon Day show at Coney Island. The show was broadcast to the entire Dumont Network.

From the 1940s through the 1960s, Cincinnati's Coney Island was the summer place to be. Moonlite Gardens, Lake Como, and lots of rides attracted thousands of Cincinnatians daily. It was also a place Cincinnati television stars came to meet fans. Paul Dixon, Dotty Mack (left), and Wanda Lewis navigate the Lost River ride during one of their many summer appearances at Coney Island to promote *Paul Dixon's Song Shop* on Channel 7.

The west side's Dorothy Macaluso, better known as Dotty Mack, was a fan favorite on Italian Day at Coney Island. Bob Braun (left) and Colin Male were on hand in August 1954 to promote their *Pantomime Hit Parade* on Channel 9 and perform live for their fans. (Courtesy Dennis Hasty.)

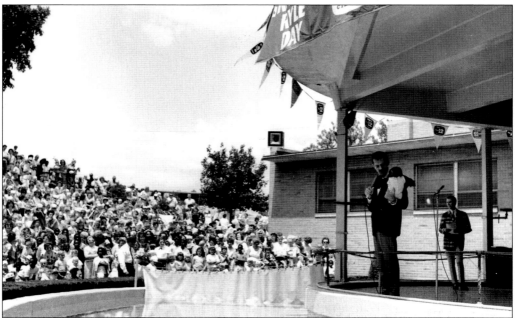

One of Cincinnati's favorite annual summer events was Skipper Ryle Day at the Cincinnati Zoo. In 1963 and 1964, *Sixteen Magazine* named *The Skipper Ryle Show* the "Best in TV." A record 25,000 loyal fans turned up at the Cincinnati Zoo for Skipper Ryle Day in 1965. (Courtesy Cincinnati Museum Center.)

In 1966, Ohio governor James Rhodes asked Avco Broadcasting to help promote the Ohio State Fair by producing live broadcasts from the fairgrounds. In 1967, WLW-T originated almost 60 hours from the fair, including *The Paul Dixon Show*, *Bob Braun Show*, and *Midwestern Hayride*. That year, the Ohio State Fair moved from 31st to 2nd in the nation in attendance, with an increase of more than 1.2 million visitors. (Courtesy WLWT.)

During the "Big Red Machine" days of the 1970s, the *Bob Braun Show* traveled to Florida each February to spend a week on the beach and visit the many Cincinnati "snowbird" fans wintering down south. Many Cincinnati Reds and Bob Braun fans planned spring break trips to catch a show and a game. (Courtesy WLWT.)

The national television networks realized that connecting local stars to national shows could attract attention, press, and, they hoped, viewers. In June 1961, *The Rifleman* star Chuck Conners, who played Lucas McCain, joined Skipper Ryle both on his *River Queen* set and in a personal appearance at Coney Island. On October 9, 1961, Ryle appeared in the "First Wages" episode of *The Rifleman* on ABC. (Courtesy the Schnitker family.)

CBS invited Cincinnati newsman Al Schottelkotte (left) to appear as a bailiff on a 1964 episode of *Gunsmoke,* the longest-running dramatic series in history. James Arness (right) played Marshall Matt Dillon all 20 years of its run. In addition to his 27 years as news anchor, Schottelkotte also appeared in a 1966 episode of *Gilligan's Island.* (Courtesy WCPO.)

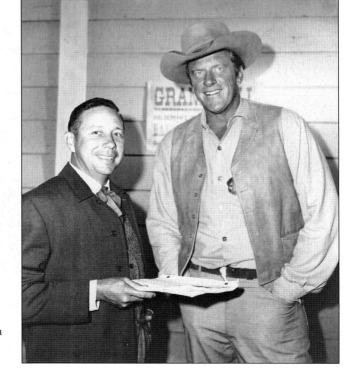

Taft Broadcasting's dedicated staff of drivers collected gifts and donations from all over Greater Cincinnati for the Neediest Kids of All in 1961. Promoted on top of the car, the *Wyatt Earp* show ran on ABC from 1955 to 1961, starring Hugh O'Brien as Marshall Earp. Albers was a popular grocery chain for many years in Cincinnati. (Courtesy Cincinnati Museum Center.)

One popular promotion in the 1950s and 1960s was using automobiles as moving television billboards. WCPO-TV used this 1953 Chevy 3100 panel truck to promote its popular teen dance show. A decade later, Channel 9 used Ford Falcon station wagons to promote *The Uncle Al Show*. (Courtesy WCPO.)

Six

WHAT'S ON

In the early days, almost all Cincinnati television was local. In August 1947, programming on experimental station W8XCT totaled only five-and-a-half hours a week. By the end of 1947 W8XCT was presenting 20 hours a week.

Every phase of life could inspire an idea for a television show. Bridge games, swimming exhibitions, baseball, football, and other sports, as well as programs based on popular parlor games were broadcast to less than 100 screens in the Cincinnati area. Since most television receivers were in bars, much of the programming was sports.

When television moved into homes, programmers needed to develop entertainment for the entire family. On its first day of television, WLW-T released its programming plan. Women's programs would be presented in the afternoon and would "include style and charm shows, tips on interior decorating, home arrangement, sewing and bridge lessons, a 'video kitchen' for cooking demonstrations, beauty hints and tips on homemaking in general."

In 1948, WLW-T was broadcasting fewer than 30 hours each week, while WKRC-TV was testing its signal four hours a day. WCPO-TV general manager Mortimer C. Watters wanted television to run like radio. He wanted programming on whenever the viewers turned their set on. Watters was famous for saying, "I don't care if it's a guy reading the phone book, I want something on whenever someone tunes in." He was open to every idea. Watters offered on-air talent blunt advice. "Do what you want to do, and if you get an audience, you'll stay on. If you flop, you're out."

Robert D. Friedman, the author's father, owned Terminix, the termite-turned-pest control company. Late in 1949, one of his suppliers sent a short film about termites. He walked the few blocks from his office on Central Parkway down to Channel 11 in the Cincinnati Times-Star building on Broadway. Friedman was sent to the control room, where he asked if the engineer had any use for the film. To Friedman's amazement, the engineer threaded the film into the projector, flipped a switch, and the film was broadcast.

From the one hour per week on W8XCT in 1946 to more than 300 hours per week decades later, Cincinnatians saw many hits and flops.

WLWT TELEVISION SCHEDULE

WEEK OF MARCH 1, 1948

```
MON - 2:30          Ball Game - (Cartoon)
      2:45          Riders of Riley -f (Camp Riley)
      3:00-3:30     Kitchen Klub

      7:30          Ball Game - (Cartoon)
      7:45          Riders of Riley -f (Camp Riley)
      8:00-9:30     Danny Boy -f (Feature)

TUE - 2:00          Using The Weather - J. Cecil Alter
      2:30          Feather Follies (Cartoon)
      2:45          Musical Havana -f (Travelog)
      3:00-3:30     Kitchen Klub

      7:30          Feather Follies (Cartoon)
      7:45          Magical Havana -f (Travelog)
      8:00          Who Am I? (Artist draws clues)
      9:00          Killers of Chaparrel -f (Nature)
      9:30-9:45     Evening at Gaylords

WED - 2:00          In Old Montana (Feature Film)
      3:00-3:30     Kitchen Klub

      7:30          Venice Vamp (Cartoon)
      7:45          Across America in 18 min. -f
      8:00          Pointed Questions (Darts, Conse-
                      quences)
      8:30-9:30     In Old Montana (Feature Film)

THU - 2:00          Man Against Microbes -f
      2:15          Cubby Stratosphere Flight (Cartoon)
      2:30          Music Box -f (Laurel & Hardy)
      3:00-3:30     Kitchen Klub

      7:30          Cubby Stratosphere Flight (Cartoon)
      7:45          Man Against Microbes -f
      8:00          Hobby Show
      8:30          Music Box -f (Laurel & Hardy)
      9:00-9:30     Musical Ponies (Studio Races)

FRI - 2:30          Future Admirals -f (Annapolis)
      2:45          Animal Fair -f
      3:00-3:30     Kitchen Klub

      7:30          Cartoon -f
      7:45          Animal Fair -f
      8:00          Future Admirals -f (Annapolis)
      8:15-11:15    Wrestling (Music Hall)

SAT - 12:45-1:00    Luncheon at the Sinton - Pogue Styles
      2:30          Typing Tips
      3:00-3:30     Kitchen Klub

      7:30          Typing Tips
      8:00          To Be Announced

SUN - 2:30          Pet Party
      3:00          Magic Art (Cartoon)
      3:15          Where Money Is Not God -f (Mexico)
      3:30-4:00     Visit With Cincinnati Churches

      7:30          Magic Art (Cartoon)
      7:45          Where Money Is Not God -f (Mexico)
      8:00          To Be Announced
```

f - film

TEST PATTERN: MON, FRI, 12-2:30 & 3:30-5:00
 TUES, WED, THURS, 12-2:00 & 3:30-5:00

In the earliest days of television, WLW-T mailed its weekly television schedule to homes in Greater Cincinnati hoping to encourage residents to purchase a set and tune in. This schedule is from the third week of commercial television in Cincinnati. (Courtesy Dennis Hasty.)

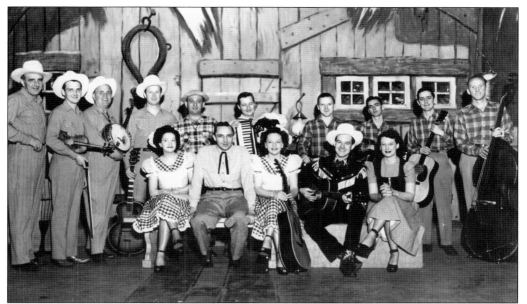

Midwestern Hayride was originally called *Boone County Jamboree* when it began on WLW radio. It premiered on WLW-T in August 1948 and ran for 24 years. Pictured, from left to right, are (first row) Lorriane DeZurik, Ernie Lee, Carolyn DeZurik, Kenny Roberts, and Judy Perkins; (second row) Jack Taylor, Wally Moore, Chick Hurt, Rusty Gill, host Willie Thall, Buddy Ross, Jerry Bird, Zeke Turner, Louis Innis, and Red Turner.

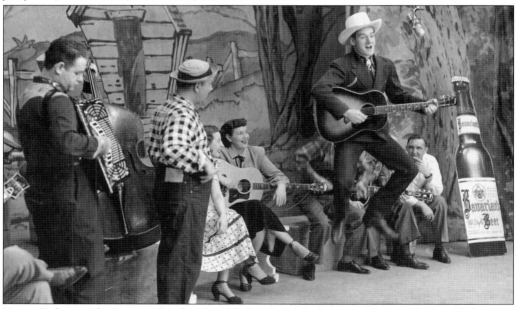

Kenny Roberts, "the Jumpin' Cowboy," yodeled tunes while jumping. Here in 1949 on *Midwestern Hayride*, he performs with Mike Wilson (with the accordion) of the Trailblazers, host Willie Thall, Judy Perkins, Dollie Good from the Girls of the Golden West, and vocalist Ernie Lee. In 1953, Roberts returned to Cincinnati and had a television show from 5:00 p.m. to 5:45 p.m. on WKRC-TV with a mixture of music and a "hayseed" comedian.

At six feet two inches and 300 pounds, country singer Kenny Price is best known as the "Round Mound of Sound" on *Hee Haw*. Born in Covington, Kentucky, Price's dream to be a farmer got sidetracked when he joined *Midwestern Hayride* in 1954. Here Price (with the guitar) poses with Hometowners Buddy Ross (holding the accordion), Freddie Langdon (on bass), and Jay Neas, who specialized in high yodeling. (Courtesy WLWT.)

On June 16, 1951, *Midwestern Hayride* made its national television debut as an NBC summer replacement series for Sid Caesar's *Your Show of Shows*. A year in advance, 100 weekly studio audience tickets were sold out. Avco Broadcasting syndicated the show in the 1960s. Big stars visiting the fifth-floor Crosley Square studio on Saturday nights included Tex Ritter, Dolly Parton, Porter Wagoner, and Willie Nelson. *Midwestern Hayride* ended in 1972 after 24 years. (Courtesy WLWT.)

Barnyard Frolic was another "hillbilly music show" filling the grid in the early days of Cincinnati television. Starring the Echo Valley Boys, the show aired weeknights at 7:00 on WKRC-TV. Pictured here, from left to right, are Bill Thomas, David "Lefty" Combs, Preston Ward, Dollie Good, Jimmy Watson, Leo "Groundhog" Kidd, and "Little Joe" Ward. They also appeared on WKRC-TV's *Hi Neighbor* with host Paul Hodges. (Courtesy Regina Ward Copenhaver.)

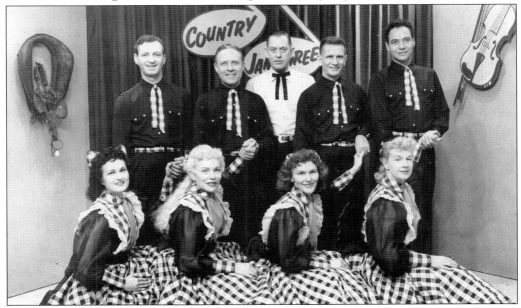

At WLW-T, Willie Thall had starred with Bob Shreve on *General Store*, hosted *Midwestern Hayride*, and cohosted with Ruth Lyons. In 1957, after seven years with the *50-50 Club*, Thall left to host his own hillbilly show, *Country Jamboree*, on WKRC-TV. The show, which often included the popular square-dancing group the Kentucky Briarhoppers (above), lasted only 13 weeks. (Courtesy Faye Dorning.)

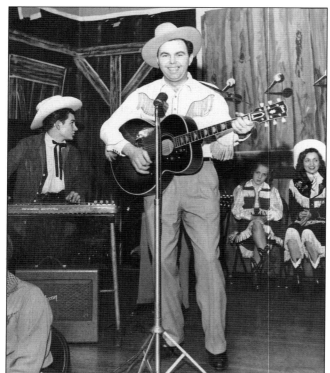

At WCPO-TV, Big Jim Stacey appeared on 18 hillbilly music shows each week. There was the *Merry-Go-Round, Cornhuskers Jamboree*, the *Breakfast Club, Banjo Moods*, and an 11:00 p.m. square dance, which he also hosted. He stayed at WCPO-TV for 11 years and was best known as the 1950s host of *Six Gun Theater* where he stood on a cardboard set and talked about the B western movie being aired.

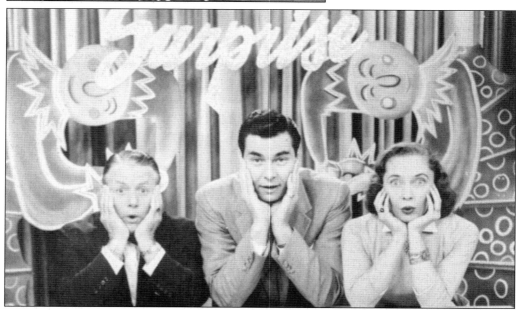

Colin Male (center) was a private investigator from Buffalo, New York. He became one of WCPO-TV's most popular stars. In addition to his audience participation show, *Surprise*, costarring Bob Shreve and Wanda Lewis, Male had a daily children's cartoon show, *Colin Callin'*, and delivered the sports report five days a week on *Sports Final*. After leaving WCPO-TV for Hollywood, Male provided the voice for the opening of *The Andy Griffith Show*. (Courtesy WCPO.)

Bill Dawes was a disc jockey at WCPO radio in 1949 when general manager Mortimer C. Watters asked him to fill an hour of television in addition to his daily radio show. Rosemary Olberding had just graduated from the College of Mount St. Joseph and was working in the WCPO music library. The two were paired to pantomime records one hour each day on *Bill Dawes' Ballroom*.

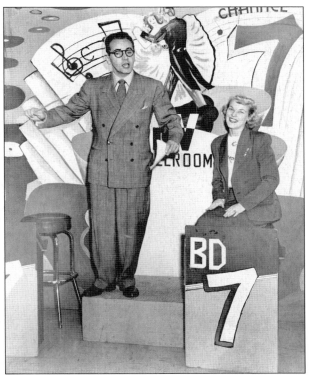

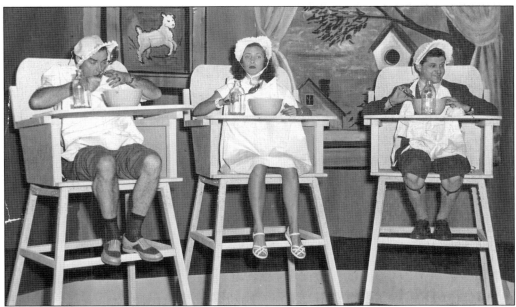

On WCPO-TV many of the early shows included pantomime where performers appeared to be singing but were lip-syncing to records. The shows were so good and so popular that producers from across the country visited the WCPO-TV studios to study their process. Pictured here in a 1953 episode of Paul Dixon's show, Dixon (left), Lewis, and Len Goorian prepare to pantomime "Triplets" from Fred Astaire's *The Band Wagon*.

Dorothy Macaluso grew up on Cincinnati's west side and was prom queen at Mother of Mercy Academy. On May 3, 1948, the Jenny Company (later Gidding-Jenny) dressed the windows of their downtown clothing store with real women, including Macaluso (pictured), posing as mannequins. She caught the eye of WCPO-TV general manager Mortimer C. Watters, who offered her $50 a week to work at the station. Watters changed Macaluso's name to Dotty Mack, and she made her debut two hours after WCPO-TV signed on, becoming "local television's first glamour girl." After four years with Paul Dixon, Mack got her own show, *Pantomime Hit Parade,* from 10:30 p.m. to 11:30 p.m. Mack became a national star, and local stations across the country began producing pantomime shows. She often joked that she was the creator of MTV. (Above, courtesy Cincinnati Post.)

Pantomime Hit Parade premiered in February 1953 with cohosts Colin Male (right) and Bob Braun, who later was replaced by Bob Smith (left). Dotty Mack also starred in a 15-minute program, *Girl Alone*, on the Dumont Network until June 1953, when it expanded to half an hour and Braun and Male joined the cast. The title was changed to *The Dotty Mack Show* and aired on ABC until September 1956. (Courtesy Dennis Hasty.)

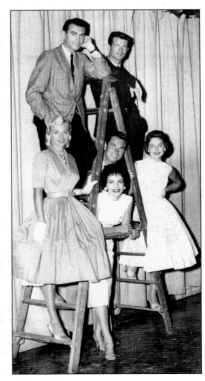

Dotty Mack left WCPO-TV in 1957, but the pantomiming did not end. Channel 9 created a new pantomime show called *This is Music*. It ran on WCPO-TV weeknights from 10:55 p.m. until midnight and on the ABC network on Mondays from 7:30 p.m. to 8:00 p.m. The stars, pictured from left to right, are (first row) Gail Johnson, Ramona Burnett, and Paula Jane. Colin Male is in the middle with Bud Chase (top, left) and Bob Smith.

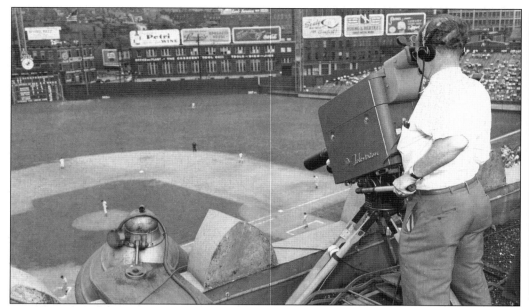

Cincinnati Post sports editor Joe Aston was cautious about the coming of sports on television. He wrote, "Baseball reception is perfect up to a certain point. As long as the ball stays in the infield, there isn't much missed. Fly balls to the outfield complicate things considerably." WLW-T broadcast 32 Cincinnati Reds games from Crosley Field in 1948, using only three cameras to capture the action. The cameraman is Bob Brockway. (Courtesy WLWT.)

Another early television favorite was Friday night wrestling matches on WLW-T live from Music Hall Sports Arena. Vernon "Red" Thornburgh was the first wrestling announcer on W8XCT in 1947. In 1950, Thornburgh quit his job at WLW-T when he was replaced as wrestling show host. After three years of pioneering Cincinnati television sports, Thornburgh was rarely seen on television again. (Courtesy Cincinnati Museum Center.)

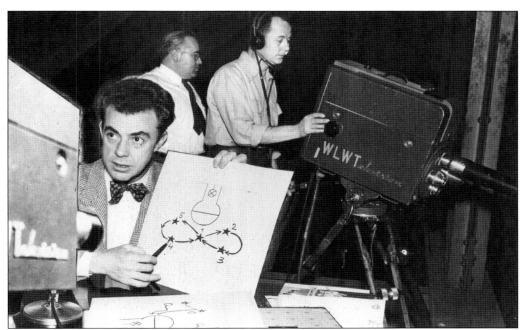

Sports announcer Thornburgh found a place in the rafters of the Xavier University Armory Fieldhouse to televise WLW-T's first basketball game in 1948. Lee Lampkin operates the camera with engineer Russ Witt watching. (Courtesy Cincinnati Museum Center.)

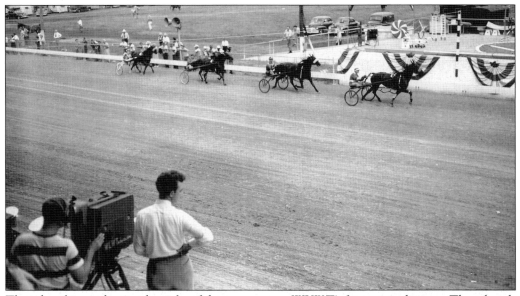

Thornburgh, standing to the right of the camera, was WLW-T's first sports director. Thornburgh looked for every possible way to bring different sports to television. Here in August 1948, he covers harness racing at the Carthage Fair. In his three years at W8XCT and WLW-T, Thornburgh hosted and produced the first live televised bowling, boxing, football, swimming, and wrestling events. He also organized the telecast of Cincinnati's first Harlem Globetrotters game. (Courtesy Cincinnati Museum Center.)

WLW-T considered audience participation programs a television natural. *Who Am I?* was created and hosted by Red Thornburgh. Rudy Prihoda drew the clues while Thornburgh called someone from the limited viewing audience and awarded prizes for solving a rebus of a famous person. The answer to the puzzle is Cincinnati Reds third baseman, Grady Hatton. (Courtesy Cincinnati Museum Center.)

Dave Stanley and Kathy Wynn hosted *Fun 'n Facts*, a 1956 WCPO daily show promoted as "an educational yet entertaining program designed to please the whole family." Pictured here is the WCPO engineering staff with the show stars, including, from left to right, Ed Stupak, Harold Briggs, Martha Ransohoff, unidentified, Len Cunat, Wynn, Larry Pierce, Stanley, Joe Fojtik, and Bob Dixon.

The afternoon game show *Cinderella Weekend* ran for several years on WKRC-TV in the early 1950s. Hosts George Bryant and Shirley Jester asked questions of members of the studio audience with the winner receiving an all-expense-paid trip for two to New York City. (Courtesy George Bryant.)

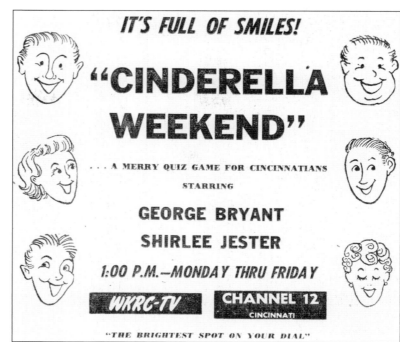

IT'S FULL OF SMILES!

"CINDERELLA WEEKEND"

... A MERRY QUIZ GAME FOR CINCINNATIANS

STARRING

GEORGE BRYANT

SHIRLEE JESTER

1:00 P.M.—MONDAY THRU FRIDAY

WKRC-TV CHANNEL 12 CINCINNATI

"THE BRIGHTEST SPOT ON YOUR DIAL"

Wirt Cain arrived in Cincinnati from Oklahoma in 1969, hoping to become WCPO-TV's behind-the-scenes announcer. He became one of the favorite faces on several shows. During commercial breaks on the *Early 9 Movie* weekday afternoons, Cain called viewers and gave away prizes. For several years he hosted a game show on weeknights at 7:30 called *What Would You Say?*, which was a combination of *Truth Or Consequences* and *Beat The Clock*. (Courtesy Bill Renken.)

The first-ever Cincinnati telethon aired all night December 11, 1949, on WCPO-TV to raise money for the Post-Firemen's Mile of Dimes charity. Paul Dixon auctioned his necktie for $50. A Wanda Lewis charcoal sold for $100. Harris Rosedale auctioned a dance, Paul Dixon auctioned a pantomime, and one viewer offered to buy Coco the Clown's glasses. Five viewers bid on Jim Fair's barrel. WCPO expected final contributions to total several thousand dollars.

After the success of the Post-Firemen's Mile of Dimes telethon, WCPO presented many other telethons. The 1954 Poliothon raised more than $60,000. Here Colin Male talks to the television audience in WCPO-TV's *All Star Celebrity Telethon for Big Brothers*.

In the early days of WLW-T, Charles Vaughan produced and directed many shows, including *Straw Hat Matinee*, *Midwestern Hayride*, and *Melody Showcase*. In 1966, as WCET general manager, he was instructed to close the station when funding diminished. Instead Vaughan created membership drives, enlisting more than 40,000 supporters, and increased educational programming. Vaughan also established the *Action Auction*, building it into the largest auction in the public broadcasting system. (Courtesy WCET.)

More than just a fund-raiser, WCET's *Action Auction* was the biggest on-air neighborhood television party. This total community event began in 1968 to raise money for Cincinnati's public television station. While it was never great television, no one seemed to mind. Hundreds of volunteers from families, schools, businesses, and civic organizations annually donated auction items, answered telephones, and appeared on camera for the auction that, in many years, ran for 10 days. (Courtesy WCET.)

On Saturday afternoons in 1958, WCPO-TV presented *Bud Chase's Swap Shop* where viewers would buy, sell, and trade their treasures. On this April episode, Albert Risch (left) of Covington stands with show producer John Clark, host Bud Chase, and Zero, the Tennessee walking horse that Risch had offered for swap. Viewers were willing to trade cars, cash, a motorcycle, and a cow for Zero.

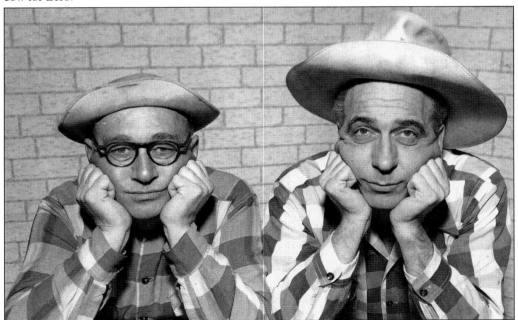

Willie Thall and Rink's founder Hyman Ullner, known as the Bargain City Kid, hosted *Shock Theatre* Fridays at 11:30 p.m. on Channel 9. The Bargain City Kid was known for throwing pots, pans, clothes, and other Rink's on-sale merchandise at the television audience. The duo also emceed *Rink's Big Time Wrestling* on Saturday afternoons in the 1960s.

Throughout the 1960s and 1970s, Kash D. Amburgy, the "Ole Country Boy" from Lebanon, became a household name while touting his furniture and appliance store. He delivered his commercial messages in the rapid-fire cadence of a preacher at a tent revival, with his wife, Mary Lou, beside him. His closing line was "Follow the arrows, follow the signs to Kash's Big Bargain Barn in South Lebanon, Ohio, where you save cash with Kash."

Mike Tangi left WCPO-TV in 1963 to run his own advertising agency. In the early 1970s, searching for a campaign for King Kwik Minit Markets, he created the concept of twin brothers singing. When casting did not produce the twins he wanted, Tangi cast himself in both roles. He knew enough about television production to make twins out of himself. The client loved it, and the Kwik Brothers were born. (Courtesy Mary Lynn Tangi.)

According to FCC regulations, television stations must identify themselves as close to each hour as possible. Viewers grew accustomed to Skipper Ryle's Tall 12 WKRC and Todd Hunter's Channel 9 station identifications. WLW-T announcer Hal Woodard found an innovative way of presenting station breaks without words with the help of Channel 5 art director Rudy Prihoda.

The WLW stations never missed an opportunity for cross-promotion, as was the case when the announcer would say, "As WLW-T leaves the airwaves, we invite you to turn to 700 on your radio dial to hear Bill Myers and Music 'til Dawn, sponsored by American Airlines." Then WLW-T signed off, hoping that viewers would turn to its radio sister station 35 hours a week. (Courtesy Bill Myers.)

While most Cincinnatians knew her as Captain Windy from *The Uncle Al Show*, Wanda Lewis held many jobs on air and behind the scenes at WCPO-TV during her 40 years at the station. From 1956 to 1962, Lewis hosted Channel 9's daily afternoon *Movie Matinee*. Lewis presented live commercials, talked about the movie, and awarded prizes to viewers.

Most movie presentations during the early days of Cincinnati television had a host. At WLW-T, Bob Braun hosted the late-night *Movietime* and the afternoon *Gold Cup Matinee* with Judy Perkins. Reminiscent of his days with *Pantomime Hit Parade*, Braun and Perkins dressed up in costumes to fit the movie presentation. This provided additional entertainment for viewers as the two talked about the movie and had fun with the commercials. (Courtesy the Braun collection.)

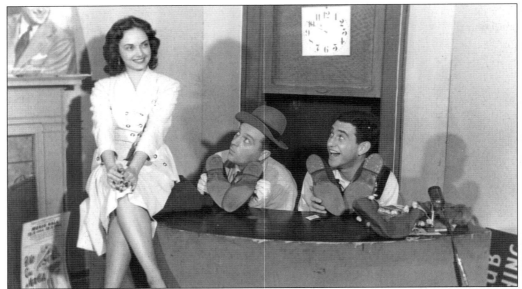

Soupy Sales's first television series, *Soupy's Soda Shop*, on WKRC-TV was a ratings disappointment. So Sales created a 45-minute late-night show called *Club Nothing*, which was spiced with comedy routines, guests, and music. The show, starring Sales (right) using the name Soupy Hines, with George Brengel and Peggy Berlaw, lasted one season before the show was cancelled and Sales moved away to become the "pie-in-the-face" king of television. (Courtesy Cincinnati Museum Center.)

Willie Thall (right) and Bob Shreve played the characters Willie and Elmer who tended to the Broken Tooth General Store on WLW-T's early rustic situation comedy show *General Store*. Shreve and Thall, here with radio, television, movie, and recording star Beatrice Kay in May 1950, performed skits and sang hillbilly songs on the unscripted weekday 15-minute show on Channel 4.

In 1949, Rod Serling (second from left) was a $75-a-week staff writer at WLW radio while writing television dramas from his suburban Wyoming home. After more than 40 rejections, Serling sold the scripts to WKRC-TV; 52 were presented in an anthology series called *The Storm*, which aired until 1953. The 1952 episode titled "The Time Element" was rewritten as the pilot episode of *The Twilight Zone* on CBS in 1958. (Courtesy Sanders Media Archive.)

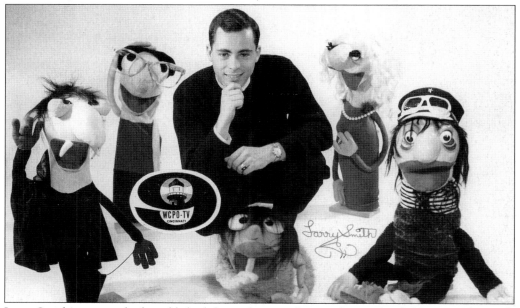

Larry Smith's puppets had established themselves as a favorite feature for children on *The Uncle Al Show* from 1957 to 1960 on Channel 9 and on *The Rudy and Teaser Show* on Channel 12 in 1961. Seeking an adult audience, Smith created *The Contemporaries*. From 1962 to 1963, 30 episodes aired weekly on WCPO-TV. The contemporaries were large, soft, humanoid figures that pantomimed to novelty songs and comedy routines. (Courtesy WCPO.)

Church By the Side of the Road began on WLW radio in 1923 and added a television program in 1949. It aired at 8:30 on Sunday mornings. Religious leaders were severely criticized in the early days for appearing on an "entertainment media." A 65-voice choir composed entirely of Crosley Broadcasting Corporation employees furnished the music for the weekly program. (Courtesy WLWT.)

In 1967, WLW-T signed on the air weekday mornings at 6:55, five minutes before NBC's *Today Show*, to present *Five Minutes to Live By*. Howard Chamberlain (right), Channel 5 senior staff announcer, hosted the inspirational program each morning. On this April 14, 1967, episode, Chamberlain is joined by Fr. Ulmer Kuhn of Cincinnati's Franciscan Information Office. (Courtesy WLWT.)

Xavier Presents was a weekly variety show that aired on WCPO-TV during the early years of television. More than 250 students helped produce the weekend show featuring music, skits, dramatic presentations, interviews with celebrities, campus information, and comedy acts. Xavier University invited students from the University of Cincinnati, Our Lady of Cincinnati College, the College of Mount St. Joseph, Villa Madonna College, Schuster-Martin School, Miami University, and others to participate on the show. (Courtesy Xavier University.)

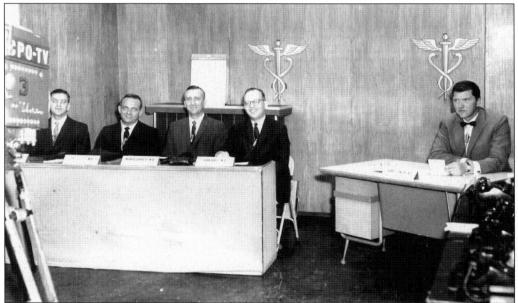

Albert Thielen, a Northside doctor for 41 years, may be best remembered as creator and moderator of WCPO-TV's *Call the Doctor*. Airing on Sunday mornings as a half-hour program, it was so popular that it was expanded to 45 minutes in 1961 and, finally, to one hour. Viewers called to ask questions of the Academy of Medicine of Cincinnati panel. Thielen moderated the show for its entire run from 1960 to 1982.

As television neared the end of its first decade, the schedule settled into familiar patterns programmers found that connected with viewers' lives. WCPO-TV morning shows focused on children with a double dose of Uncle Al. Cincinnati children sat with their milk glass, waiting to toast the day by touching their glass to the television screen when Colin Male touched his to the camera on *Colin Callin'*. (Courtesy Dennis Hasty.)

In 1962, Gene McPherson started the documentary unit at WLW-T to create filmed programs looking at serious issues facing Cincinnati. *Emergency* (right) investigated Cincinnati's hospitals and aired at 10:00 p.m. on October 6, 1963. McPherson also wrote, directed, and produced *The Last Prom* and many other *Young People's Specials* and documentaries. (Courtesy WLWT.)

In 1979, Dan Hurley was the education coordinator at the Cincinnati Historical Society when WCPO-TV asked him to write and produce a history of Cincinnati. The six half-hour episodes aired on consecutive Saturday nights in 1981. A seventh episode was produced later that year. CBS's Charles Kuralt (left), with Hurley in November 1980 at the Cincinnati Union terminal, hosted the series. (Courtesy Cincinnati Museum Center.)

In the late 1960s, Lilias Folan (left) was teaching yoga when student Myrll Goorian suggested that her husband, Len Goorian, produce a yoga segment for PBS. Goorian had produced many successful shows, including the original Paul Dixon show on WCPO-TV and his own *Len Goorian Show* on WKRC-TV. Goorian and Folan created *Lilias, Yoga and You*, premiering on WCET in 1972. It also was fed from the Channel 48 studios to a national PBS audience from 1976 to 1992.

Bob Shreve will best be remembered as the host of the all-night *Past Prime Playhouse* on WKRC-TV from 1974 to 1985. The movies were really bad, but dedicated fans made Saturday overnight on Channel 12 the place to be for their weekly dose of bad one-liners, sound effects, Speidel the spider, Chickee the rubber chicken, and a bloody, one-eyed, ghoulish head named Gororo that lived in a box. (Courtesy Cincinnati Post.)

PM Magazine began in Cincinnati in 1979 on WKRC-TV with hosts Janet Davies (above) and Steve Deshler. Each weeknight they visited a different location to introduce stories produced locally and by *PM Magazines* around the country. The show presented Cincinnati people and places for six years and, during its run, was hosted by Tony Dale, Edie Robinson, Ira Joe Fisher, Laura Soller, Doug Waldo, Jerry Thomas, and Joyce Wise. (Courtesy Janet Davies.)

As Cincinnati television stations focused more on news, they turned over much of the schedule to syndicated programming and the networks. WCPO-TV presented dozens of local primetime specials created by the *Celebrate Cincinnati* team from 1985 until 1992, including *First Day*, *The Magic of Television*, and *Traditions*. Pictured, from left to right, are (second row) Bob Ciolino, Cheryl Jacobs, and Jeff Miller; (first row) Joe Perdue and Jim Friedman.

ACROSS AMERICA, PEOPLE ARE DISCOVERING
SOMETHING WONDERFUL. *THEIR HERITAGE.*

Arcadia Publishing is the leading local history publisher in the United States. With more than 3,000 titles in print and hundreds of new titles released every year, Arcadia has extensive specialized experience chronicling the history of communities and celebrating America's hidden stories, bringing to life the people, places, and events from the past. To discover the history of other communities across the nation, please visit:

www.arcadiapublishing.com

Customized search tools allow you to find regional history books about the town where you grew up, the cities where your friends and family live, the town where your parents met, or even that retirement spot you've been dreaming about.